ADDENDUM TO THE CHECKLIST OF
THE MICHAEL AND DOROTHY BLANKFORT COLLECTION

ARMAN (ARMAN FERNANDEZ)
French, b. 1928

• I. *Untitled*, c. 1966
Tubes of paint embedded in acrylic
11⅛ x 2⁵/₁₆ x 1⁹/₁₆ in. (28.2 x 5.8 x 4 cm.)
Provenance: James Waterman Wise, Geneva.

CAROLE CAROOMPAS
American, b. 1946

• II. *G* (from the series *A Hermetic Romance from A to Z)*, 1981
Acrylic, gouache, and mixed media
38 x 25 in. (96.6 x 63.5 cm.)
Provenance: Jan Baum Gallery, Los Angeles.

ANDREA CASCELLA
Italian, b. 1920

III. *Untitled*, 1959
Pencil
18¾ x 14⅝ in. (47.6 x 37.1 cm.)
Provenance: Gift of the artist.

ERTÉ (ROMAIN DE TIRTOFF)
French, b. Russia, 1892

• IV. *Letter B*, c. 1925
Lithograph, artist's proof
19¾ x 13⅞ in. (50.2 x 35.3 cm.)†
Provenance: Gift of the artist.

CONNOR EVERTS
American, b. 1928

V. *Untitled*, c. 1965
Lithograph, presentation print
15 x 11¼ in. (38.1 x 28.5 cm.)
Provenance: Gift of the artist.

JOE GOODE
American, b. 1937

VI. *War Babies*, 1961
Lithograph 2/20
22¼ x 15 in. (56.5 x 38.1 cm.)
Provenance: Huysman Gallery, Los Angeles.

R. B. KITAJ
American, b. 1932

• VII. *The Hand of Matisse*, 1980
(inscribed "love, ever for Dossy and Mike")
Screenprint 6/15 (published by Marlborough Graphics)
28½ x 22⅛ in. (72.4 x 56.2 cm.)
Provenance: Gift of the artist.

GARY MARCHAL LLOYD and **PETER CLOTHIER**
American, b. 1943; American, b. England, 1936

• VIII. *Bob Went Home*, 1975
Mixed-media book 3/100
(published by Ellie Blankfort Gallery)
15⁷/₁₆ x 14⅛ x 4 in. (39.2 x 35.9 x 10.2 cm.)
Provenance: Ellie Blankfort Gallery, Los Angeles.
Literature: Young, Joseph E., "Reevaluating the Tradition of the Book," *Art News,* March 1975, p. 44.

LOUISE NEVELSON
American, b. Russia, 1900

• IX. *The Magic Garden*, c. 1955
(inscribed "To 'The Strong Hand of Michael & Dorothy Blankfort' with love Louise Nevelson")
Etching 1/20
19¹⁵/₁₆ x 25⅞ in. (50.7 x 65.7 cm.)
Provenance: Gift of the artist.

RICHARD PETTIBONE
American, b. 1938

• X. *Untitled*, 1963
Mixed-media construction
10⁵/₁₆ x 13⁵/₁₆ x 2⅝ in. (26.8 x 34.4 x 6.7 cm.)
Provenance: Ferus Gallery, Los Angeles.

ARTHUR SECUNDA
American, b. 1927

XI. *Memory of an Aftermath* (Watts series), 1965
Collage and acrylic on canvas
16¼ x 14⅛ in. (41.3 x 35.8 cm.)
Provenance: Acquired from the artist.

THE
MICHAEL AND DOROTHY BLANKFORT COLLECTION

Maurice Tuchman and
Anne Carnegie Edgerton
with an introduction by
Michael Blankfort

Los Angeles County Museum of Art

This exhibition has been made possible by a grant from the Brotman Foundation of California.

Cover: R. B. Kitaj
Dismantling the Red Tent, catalogue
number 86

Library of Congress
Cataloging in Publication Data

Main entry under title:

The Michael and Dorothy Blankfort Collection.

 Catalog of an exhibition.
 Includes bibliographical references.
 1. Art, American—Exhibitions. 2. Art, Modern—20th century—United
States—Exhibitions. 3. Art, Modern—20th century—Exhibitions. 4.
Blankfort, Michael, 1907– —Art collections—Exhibitions. I. Tuchman,
Maurice. II. Edgerton, Anne Carnegie, 1941– . III. Los Angeles County
Museum of Art.
N6512.M48 709'.04'0074019493 81-23629
ISBN 0-87587-106-2 AACR2

Published by the
Los Angeles County Museum of Art
5905 Wilshire Boulevard
Los Angeles, California 90036

Copyright © 1982 by
Museum Associates, Los Angeles County Museum of Art

Curatorial liaison for the publication:
Anne Carnegie Edgerton

Edited by Aleida Rodríguez

Designed in Los Angeles
by Anna Tartaglini

Text set in Bembo typefaces
by RS Typographics, Los Angeles

Printed in an edition of 3,000
by George Rice & Sons, Los Angeles

EXHIBITION DATES: April 1 – June 13, 1982

CONTENTS

PREFACE

We take great pride in presenting the Michael and Dorothy Blankfort Collection in its entirety for the first time. The collection, which contains works by some of the masters of American art as well as works by a wide range of contemporary artists, reflects the intellect and humanity of the collectors. It is particularly gratifying that this very personal, diverse, and distinguished collection, assembled in Los Angeles over the past twenty-five years, will remain in this city for the enjoyment and edification of future generations.

The Blankforts have been friends and enthusiastic supporters of the Museum for more than two decades. They were both founding members of the Modern and Contemporary Art Council; Dorothy Blankfort was one of the council's first presidents and is still active on the Membership Committee. Michael Blankfort is a Museum trustee and currently chairman of the Exhibitions, Publications, and Programs Committee.

Energy, dedication, and a spirit of inquiry have characterized Michael Blankfort's long and productive career as a novelist and screenwriter. Both he and Dorothy have pursued learning about and acquiring modern art with the same intensity they have applied to their own careers. Dorothy Blankfort's career as a literary agent led her naturally into the role of archivist of the collection. She has assembled an extensive library of catalogues and other documentation pertaining to the artists represented in the collection. The Blankforts have made lasting friends of many of the artists whose works they own, and have contributed in many ways to the cultural life of the city of Los Angeles.

The Blankforts have chosen together what they love, and they now give their collection to the people of their city to enjoy.

EARL A. POWELL III
Director

ACKNOWLEDGMENTS

Michael and Dorothy Blankfort have contributed greatly to the preparation of this catalogue over the past several months through their hospitality, warmth, and unfailing enthusiasm for the project. Dorothy's archives have been invaluable as a source, and she has been extraordinarily generous with her time, reviewing the checklist repeatedly and answering hundreds of questions thoroughly and with acuity. As usual, all Museum departments performed their functions efficiently, helping this project to go smoothly. Exceptional skill and initiative shown by Museum photographers Lawrence S. Reynolds and Peter M. Brenner helped to produce Kent Kiyomura's fine prints which illustrate this catalogue. This publication also owes a great deal to the meticulous editing of Aleida Rodríguez and the creative design of Anna Tartaglini.

Our new Assistant Curator of Twentieth-Century Art, Anne Edgerton, joined the staff of the Museum during the summer of 1981 and immediately absorbed herself in this project with remarkably effective results, as witnessed in this publication by the keen professionalism of her catalogue entries, and by her complete dedication to all aspects of the exhibition as well.

MAURICE TUCHMAN
Senior Curator, Twentieth-Century Art

Robert Graham
American, b. Mexico, 1938
Los Angeles County Museum of Art
Modern Art Patron Award, 1980
Painted and gilded bronze
15⅝ x 3½ in. (39.7 x 8.9 cm.)

FOREWORD

When I first met Dorothy and Michael in 1964, directly upon coming to Los Angeles from New York City, I remember being impressed by the high seriousness they manifested about viewing art, visiting galleries and studios, collecting and discussing art from multiple viewpoints, and affirming their commitment to artists through their patronage. For the Blankforts, the art experience had become embedded into the texture of their lives. They spoke of painters and paintings with enthusiastic curiosity; if they were perplexed by a work of art they were, then, all the more intrigued. At a time in America's ascendancy in the art world, and of Los Angeles' first moves toward national significance, the Blankforts' dedication struck me as a real harbinger of the city's growth. These are collectors for whom an acquisition has been a statement, and an explanation of their own feelings, as well as a symbol of their response to individual work. Michael feels that the art of collecting "has been an elevating factor in the lives of collectors [they] know—that no matter the original motive for collecting, ultimate exposure to art nurtures the spiritual aspect."

Dorothy has been chair of the Museum's Modern and Contemporary Art Council and remains an active member; she was also an effective and highly regarded literary agent during her professional career. Michael is a prominent novelist and screenwriter as well as a devoted governor of the Academy of Motion Picture Arts and Sciences and trustee of this Museum. In their dual roles as artistic representatives on the one hand, and dispassionate executives on the other, both Michael and Dorothy have created a model persona of intense engagement without self-aggrandizement. As chair of the council, Dorothy always knew where everything was—from commissioned artworks we were selling for acquisition funds, to long-lost minutes that could affect our current decisions. She combined tenacity and an eye for detail with the light touch of a diplomat. On a trip to private and public collections in France, Switzerland, and Italy a few years ago, on which I accompanied council members, Dorothy was my own private fail-safe, my comrade, helping to present a bright view of Los Angeles to the European art capitals. Michael was, and is, the kind of trustee curators cherish for his sympathetic understanding of the art historical and managerial aspects of a curator's role. My regular conversational sessions with Michael throughout the seventies characteristically began with a review of world politics, then flowed into matters concerning art exhibition scheduling, and concluded with prognoses for the future of the Museum. Clearly, the Blankforts' spirit of enlightened, critical support has been essential in the maturing of the Museum. Their contribution was acknowledged in 1981, when they were the recipients of the Museum's Modern Art Patron Award, a bronze sculpture created by noted artist Robert Graham.

In reviewing the themes of Michael's thirteen novels which span over four decades, from *I Met a Man* of 1937 to *An Exceptional Man* of 1981, one salient feature recurs constantly: a character or an idea that goes against the grain. Indeed, rebelliousness comes to be seen as something necessary for the health of society. It is this very quality that comprises the raison d'etre of the Blankforts' collection of images. Whether the artist is Kitaj, representing history and intellectuality at one end of the polarity, or Edward Kienholz, embodying direct emotionalism at the opposite end, the Blankforts have been drawn in the past two decades to art that addresses basic issues in society.

One hundred seventy-eight works by one hundred artists comprise the collection at this time. The Blankforts are as open as ever to the work of new artists as well as to new work by artists already in their collection. They are not biased against the young and untested, nor are they indifferent to older artists whose work they may not have responded to earlier. Many of the artists in the collection are Los Angeles artists, but the viewer of this exhibition will not, I think, feel that Michael and Dorothy have acquired art out of local pride or other non-artistic reasons; the collection reflects a search and a passion, not a political statement or sentimental exercise. It is above all a *personal* collection, and my colleagues regard it as highly as I do for its unique quality of being an authentic expression of the collectors' concerns. By any standard, there are great works in this collection. Willem de Kooning's *Montauk Highway* of 1958 marks a high moment in this modern master's "abstract landscape" period. De Kooning is also represented by two oils on paper, four drawings, a bronze sculpture, and two lithographs. Arshile Gorky's marvelous oil sketch for *The Calendars* is an important study for one of the artist's destroyed masterpieces; there is also a large drawing on one of the artist's last themes. Yves Klein, whose relationship with the Blankforts is vividly recalled in Michael's introduction to this catalogue, is seen in three characteristic works. The Blankforts acquired a major painting by R. B. Kitaj, *Dismantling the Red Tent,* very early in his illustrious career, before the Kitaj survey show at the Museum (our first contemporary exhibition) in 1965. Kitaj was to become a favorite artist and friend, and is well represented here by twelve early collage screenprints, a remarkable book-cover series, a charcoal drawing, and a recent luminous pastel portrait of Sandra Fisher and Frank Auerbach. Los Angeles' premier painter, Richard Diebenkorn, is seen in an oil painting and three works on paper, including an important early figurative drawing. Appropriately, Edward Kienholz, who influenced the Blankforts both as a dealer and as an artist, is represented by eight works that span the artist's mature work. The reader will enjoy the story of Michael's adventurous acquisition of an important Kienholz in his memoir in this catalogue. This work, *The American Way, II,* was exhibited shrouded in 1966 and now it is to be seen revealed at last.

Important work by still other Los Angeles artists of first importance include early and mature oils by John Altoon and Billy Al Bengston; one of Michael's first acquisitions was the Bengston painting that has hung in his Beverly Hills office for over two decades. Avigdor Arikha's *Anne Leaning on a Table,* a 1979 gift of the Blankforts to the Museum, is one of the most brilliant and moving of this artist's current figure paintings. This oil is regarded by Arikha—as is *Montauk Highway* by de Kooning—as one of his most successful. Avigdor Arikha was, like Kitaj, first shown in the United States here at the Los Angeles County Museum of Art. There are scores of other distinctive and moving works by independent-minded and historically important New York-based artists such as Philip Guston, Anne Ryan, and Alfred Jensen. Many of these works are discussed in Anne Edgerton's catalogue entries.

The Blankforts have been keenly alert to the unfolding of new talent over the years as well. Many of the artists have already made their mark in contemporary art history, including Tony Berlant, Wallace Berman, Guy Dill, Robert Graham, Maxwell Hendler, Arnold Mesches, Terry Schoonhoven and Victor Henderson. In time to come, I expect the Blankforts will continue to intercept and hold for us poignant messages of the human spirit from artists we may not know today.

MAURICE TUCHMAN

8

CONFESSIONS OF AN ART EATER (WITH APOLOGIES TO DE QUINCEY)
MICHAEL BLANKFORT

During the twenties when I was a freshman at the University of Pennsylvania, my mother, eager to try the "waters" at Marienbad for her weight problem and to lay in a supply of Czechoslovakian linen and glassware, took advantage of my father's willingness to sacrifice anything for the education of his sons to propose an art tour of Europe. The fact that our home walls were empty of art, and, as I recall, that we were scarcely habitués of New York's museums, made no difference. My father succumbed, and my mother, brother, and I—Dad would meet us in Marienbad—departed from New York on the Italian liner S.S. Conte Biancomano one bright day in 1925.

The art tour was complete. Guidebooks in hand, we walked through the endless galleries of every major museum in Naples, Rome, Venice, Florence, Milan, Munich, Berlin, Prague, Paris, and London.

In my memory, there still live several shining episodes. One is of the octopus tank in the great Naples aquarium which joyously revived on my mind's screen the part of Blasco-Ibáñez' film *Mare Nostrum* when Barbara Lamarr and Rex Ingram gave each other a scandalous soul-kiss in front of the same tank with the same octopus waving his tentacles in a most sensuous way. I'd read the novel and could reconstruct every lascivious detail. That moment of vicarious ecstasy remains when all the Carpaccios, Giottos, and Murillos have long ago faded away.

Of the artists whose works I saw, the one who stayed with me through the wild jungle of impressions was El Greco. The distortions and dramatic colors appealed to the hungry imagination of a young man who, even then, was thinking of himself as a writer.

When we returned to New York in September, images of the El Grecos were still with me, and I went to the Metropolitan Museum to see his work again. There were none on the walls. I was told that although a few paintings were in storage, the artist was not considered important enough to exhibit. I was shocked, and even after all these years I find it so hard to believe that I'm willing to admit that I misunderstood. Perhaps I was told that the available paintings, not the artist, were not good enough to show.

Fifteen years later when my second novel, *The Brave and the Blind,* about the siege of the Alcazar during the Spanish Civil War, was published, El Greco's *Toledo,* now owned by the Metropolitan, was on the jacket.

This experience in later years made me aware of how the reputations of artists can rise and fall with shifts of taste. At Princeton, when I taught, among other things, the psychology of the aesthetic attitude based on the book by Herbert S. Langfeld, I had my fill of this question of taste. The essays of Clive Bell and Leo Stein forced me to disregard all absolute standards in this matter. Art was art, and taste was taste, and even when the twain met, the marriage was not necessarily made in heaven. I left all such questions to the vested interests of critics and museum curators.

When I left Princeton to live in New York and work as a psychologist in the New Jersey prison at Rahway, the Great Depression had already created deep shifts in the views of my generation. It shook me out of the academic world into the more immediate activism of street demonstrations for unemployment insurance and writing plays for radical theater groups. Art and beauty became, in the Marxist vocabulary of the day, class concepts. We admired without reservation the great revolutionary Mexican masters Rivera, Orozco, and Siqueiros.

I was married then to Laurette Spingarn, an artist, who had inherited a Vlaminck and an Utrillo, both in fashion at the time. They hung on the walls of our small Greenwich Village apartment, noted, if at all, by our friends as prime examples of bourgeois reaction or ignored completely during the feverish discussions of far more vital subjects such as the rise of fascism, the tragedy of Spain, the betrayal of Munich, and the imminent war. And when that expected catastrophe descended, my years in the Marine Corps making tactical films of amphibious warfare were not conducive to considerations of the more humane arts. Indeed, my mother's museums had been looted by the Nazis or were hidden in bomb smoke.

Looking back on the years from the thirties to the late fifties, I seemed to have ignored the arts, including classical music. I confess that, apart from literature, they seemed irrelevant. Not until I was able to assimilate the war storms and tragic betrayals of the two decades could I open myself to those other worlds of the senses out of which, immemorially, humans have created marvels for their own sake alone. I became aware in due time that ignoring Mozart, Monet, or Mondrian added neither strength nor virtue to the social reformer.

This leavening revelation came about, as so often happens, by the accidents of time and place.

New York, 1957, with Dorothy, whom I married in 1950; the Washington Square Outdoor Art Show; a large painting of a family standing at a street corner. Something about the intensity of their eyes, all done exactly alike, fascinated me. I bought it. (Several years passed before the artist achieved fame when he was charged with conspiring to defraud the audience of a successful television quiz show, "The $64,000 Question.")

But I had eaten of the lotus, and I soon "discovered" another artist, Joachim Probst, in the old Greer Gallery on 53rd Street. He painted highly dramatic Christ figures in a style mixing El Greco, Rembrandt, and Soutine. I still have three of his works, but I haven't seen a reference to him anywhere in the last twenty years.

By a different kind of accident, I met an old friend of the thirties, Eric Estorick, who had become a distinguished London art dealer. He offered me a Chagall gouache of the biblical Aaron for more than I could afford. Yet I bought it, knowing that I hadn't truly chosen the work but rather was chosen by the artist's reputation, a common affliction of neophyte collectors and even of those more sophisticated. "Name" value is a slippery seduction, and very few of us escape the disease of vanity.

With these paintings, my wife and I had done more than nibble at the lotus; we'd drunk some of the waters of the Pierian spring from which one had better drink deeply or not at all, according to Alexander Pope's admonitory couplet. And so we did, but with a proviso to forget "names," which we couldn't afford anyway, and look at the young artists of our own province with whom we could talk and from whom we could learn.

We started by visiting the local galleries we'd heard about—Paul Kantor, Frank Perls, Ernie Raboff, Felix Landau. As we learned later, these middlemen of art deserve more than they receive, apart from markups, for their contribution to the collector community, for their willingness to invest their money and their taste in exhibitions of younger artists, as well as for giving us a chance to see the established ones. Peace to them. We've never regretted anything we bought from them all.

Our big discovery, however, was the Ferus Gallery on La Cienega Boulevard run by Ed Kienholz and Walter Hopps, nicknamed "Chico," a reserved young man with a missionary's conviction that he had the only "truth." Every Saturday afternoon, we visited him and met the artists—Ed Kienholz, Billy Al Bengston, Robert Irwin, Hassel Smith, Ken Price, Ed Moses, Craig Kauffman, and others. Most of their work was in the abstract mode and at first incomprehensible, but Chico was prepared to answer our questions and teach us how to use our eyes. In the Ferus Gallery, I found a pioneering excitement, a commitment to the new which appealed to my radical temperament.

Finally, the day came when I timidly asked Chico Hopps the price of a painting by Bengston from his first one-man show (1958). "One hundred and twenty-five dollars." With no experience in judging prices, I checked with the agent Sam Jaffe, the only collector I knew, a man with a substantial treasury of Post-Impressionist paintings. He said that he never paid more than a hundred dollars for the work of an unknown. Fortified with his "expertise" I made the offer. I was told that Bengston, who hadn't yet made his first sale, demanded, "A hundred and a quarter or nothing!" Embarrassed that I would be exploiting an artist, I agreed to the price on the condition that Jaffe never be told how much I paid.

It was the beginning of a long, long study that has lasted to the present. We began "hopping the galleries," reading every available book and essay and art magazine. Clement Greenberg and Harold Rosenberg, the prophets of the new, were our household gods. We hoarded catalogues from the New York dealers and, of course, from The Museum of Modern Art, The Guggenheim, and the Whitney. We waited anxiously for the reviews of current local exhibits by our own critics, Henry Seldis and Jules Langsner of the *Los Angeles Times,* and by Gerald Nordland of *Frontier,* a liberal magazine edited by the most experienced collector of contemporary art among us, Gifford Phillips, nephew of the Duncan Phillips who had given Washington, D.C., a great museum. Finally, with a few other like-minded art fanatics, we helped form the Contemporary Art Council of the Los Angeles County Museum of Art. We were then a veritable *brüderschaft* of new collectors who shared one another's latest acquisitions with selfless and genuine joy. In those days of the late fifties and sixties, as far as these collectors were concerned, to buy, let us say, a Picasso print was an act of retrogression. When we brought into our home, by another happy accident, a figure drawing by the Austrian master Egon Schiele, we said very little about it to our friends; indeed, there could even have been a silent apology in our attitude. The art revolution had made abstractionist Lenins of us all.

There were, naturally, other pressing life interests—my work, domestic crises, and serious attachments to causes, such as the struggle for civil rights and the emigration of Jews and political dissidents from the Soviet Union. But, with whatever we could afford, we bought the works of known and unknown artists.

Collecting as a human act has many diverse origins. At first, we enjoyed the challenge of the new art. Artists were risking with every canvas. We didn't "dig" everything we bought, though we were caught up with the gestures, the color, the energy. With some paintings there was as much empathy as when we first saw the *Winged Victory* and felt it in the muscles of our legs. Abstract paintings and drawings permitted us to enter them with our own creative imaginations. We could see and feel elements in the works that may not have been intended but were there for us. Art was discovery—of ourselves, as well.

Later, as we became more knowledgeable, other motives, some undetected, must have been present. Vanity, for one. The pleasure of collecting takes on an edge when you've managed to get an early Kline or Motherwell, an Oldenburg or a de Kooning drawing. Nor can one avoid a sense of competitiveness, envy, or pride. Now and then one feels greed to have more and more and not miss opportunities to possess this or that work. There is also, at least in the middle phases of collecting, a secret hope that your collection will grow in value so that, if necessary, you can sell part of it to live on.

All these "feelings," it seems to me, are the human components of collecting through which one passes as if through a fever. Sooner or later, the committed collector reaches an understanding in which the works he has amassed live by themselves and can be enjoyed with a kind of purity.

I haven't included the "hunger for beauty" as a motive which engaged us. I know that some of our breed claim it as their sole impulse. I don't doubt their reasons, although they may be holding on to memories of classical aesthetics. It sounds "pure" to speak of collecting art for the love of beauty. In a sense, it isn't much different from saying, "I don't know about art, but I know what I like." It overlooks the infinite varieties of human motivation, the need for beauty not the least. But as we have seen it, my wife and I have many works that took us time to understand, to see the beauty, to sense the artist's motive in the universe of color, organization of forms, and meaning. To paraphrase Oscar Wilde—beauty is pure autobiography.

Our notion was that we were not living in a museum. The lighting in our rooms was bad. We used as a model the photographs we had seen of Gertrude Stein's collection, hanging things with scarcely breathing space between them. In a few years, we had what James Elliot, then curator of modern art at the Los Angeles County Museum of Art, called "the heaviest hung house in L.A." Little did he know what was coming.

Again, by accident. Eric Estorick, the London art dealer who had sold me the Chagall, arrived in Los Angeles to offer to a mutual friend a five-foot oil by de Kooning, *Montauk Highway,* a landscape of the late fifties. Without even seeing the painting, I asked whether I might have first refusal if my friend didn't like it, though the price was ten times what I had ever paid before, and was a strain on our budget. But I was electrified by the thought of having the work of an honest-to-God master of the school whose acolytes and friends filled my walls.

The prospective buyer turned it down; he wanted a de Kooning *Woman.* Now it was up to me. I saw a big painting with a broad, dark-grey brushstroke smashing into a sash of yellow and a smaller border of rough and brilliant blue. I saw paint that had been scraped away and paint that seemed to thrust itself through the canvas. I saw strength, even brutality, and an overall energy that dazzled even while it confused. I had seen other works by de Kooning and his peers in the New York School of Action Painting, but when faced with a chance to own the work of this master, I had to find some truth in myself. Did I want to possess it for its own sake, its vigor, daring color, and passion? Or was I being seduced by a reputation? In short, I didn't know where I stood and what I believed in. I distrusted myself, and I went to Chico Hopps for advice. He thought it a great painting and, when I still hesitated because of its price, he volunteered to become my partner.

I thought about it until I realized that his interest as a dealer was contrary to mine. He would buy it to sell; I wanted to keep it. My friend Eric Estorick helped me by offering to take back the Chagall. *Montauk Highway* still lives on our walls.

"What has reason to do with the act of painting?" William Blake asked some two hundred years ago. He could well have asked that of collecting art, for there are three occasions, at least, when I acted against all reason on pure emotion or faith, and found them profoundly rewarding, despite the fact that one had nothing to do with "art" and another consisted of the purchase of "nothing."

The first of these happened when a friend, Donald Peters, dangerously ill and in a hospital, chose to keep him company, not one of his many Cézanne, Matisse, or Picasso drawings, but a small work by an artist unknown to me. It was figurative and I was prejudiced against it. Still, I was moved by my friend's feelings. If he saw something in it to hold on to while in pain, I wanted to find out what it was and share it with him. I went to Leo Castelli's gallery to buy something from the same artist, Jasper Johns.

Later I was embarrassed, not by the ridicule of a close relative who brought me a toy store target to hang alongside the Johns, but by my collector colleagues who praised me for my brilliant pioneering. So much for "taste" in the art of collecting. (Incidentally, when we needed the money for pressing private concerns, we sold the Johns, the only valuable work we ever sold.)

The next episode, in 1960, started over a beer with Ed Kienholz, not yet well known. He asked me if I thought he would "make it." What he meant, of course, was critical appreciation of his work, sales, museum representation, and so forth. I answered promptly with enthusiastic affirmation. I truly believed he would "make it," although as a writer, knowing how necessary such encouragement could be, I'd have answered yes under any circumstances.

Kienholz then asked another question: Would I buy something from him I couldn't look at for ten years? I knew from experience, having already bought several of his works, that he enjoyed "dealing." Again, I felt I had no choice. I had spoken of my faith in his future. Now was the time to prove my sincerity, and I agreed. The "deal" was for a down payment and the balance at the end of the ten-year term.

"If you open it during that time," Kienholz added, "you pay it all and I keep the piece."

Later, when he presented the lengthy and involved written contract, I saw that the date of the "opening" was April Fool's Day, 1970.

The ten years passed like a wave of the hand while Kienholz' construction, hidden within a canvas envelope, hung around the house with the rest of the crowd. Again, we were made fun of by our friends who didn't understand that faith in an artist has to be total or it becomes speculation.

For the "grand opening" we invited all the friends who had seen the "thing" in our home. Kienholz appeared, strangely shy, but dutifully prepared to do the final unveiling. As we stood together in our garden, surrounded by an eager, skeptical audience, he asked whether I would sell the piece back to him before he opened it. For the third time, my good faith was tested and I refused.

What we saw brought gasps of appreciation as well as distaste. In the center of the construction was the gaping oval of a deer's neck, glossy brown hair and all, from which the head and all the innards had been removed. Surrounding the neck was a coil of ochre-colored rubber hose against a salmon background. The neck and the coil were contained in a painted wooden box approximately two-feet square. The title of the piece was *The American Way, II.*

I dared think that he had called it *The American Way, II* because it represented a mindless act of horror, not unlike one of Goya's drawings of war. Dorothy asked him what the title meant. "It's obvious," Kienholz replied. "The way you bought it is the American way. On the installment plan."

Despite Kienholz' claim, I still see it my way, and there's no law that says I can't. Someday it will take its place at the Los Angeles County Museum of Art alongside another work of Kienholz' called *History as a Planter,* a deeply moving memorial to those who died in Hitler's ovens, bought jointly for the Museum by some collectors among whom we were proud to be included.

A few years before, in the middle sixties, I had begun to note reviews and reproductions of an American artist living in London, R.B. Kitaj, who painted objects and figures in a way that seemed strikingly original. But what interested me as much was the humanist sensibility in the work. There seemed more to it than met the eye, and, despite my involvement with the abstract movement, I responded with sympathy. When I had a chance to talk to Lawrence Alloway, the British art critic, who had actually seen exhibitions of Kitaj, he suggested I write the artist, and a brief correspondence followed. Soon after, at the Marlborough Gallery in London, I saw the paintings live and found them more fulfilling than I had even imagined. In addition to his color sense and organization of images, he was attempting to communicate ideas without being literal or cartoonish. I couldn't help but respond, and I bought a large painting, *Dismantling the Red Tent.*

Kitaj's work became part of our lives, reminding me, now and then, of the time when the artist's eye could encompass, along with form and color, the *materia medica* of the society in which he lived. I'm not for leading a band of *sans-culottes* against abstract or minimal painting; I'm just crowding the walls with a greater variety of companions to a lonesome and magnificent drawing of Rico Lebrun's of the Spanish Civil War, *Addio Cataluña,* bought twenty years ago.

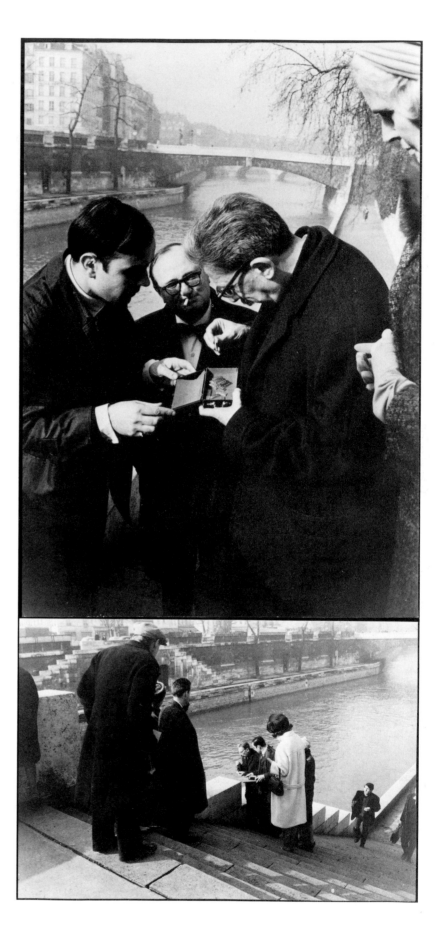

Documentary photographs of Michael and Dorothy Blankfort acquiring Yves Klein's *Immaterial Pictorial Sensitivity Zone,* Paris, 1962

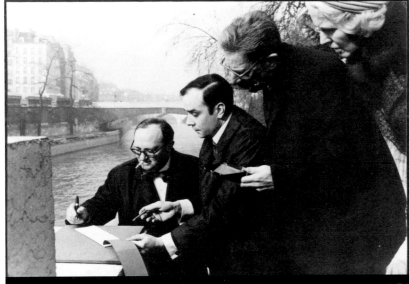

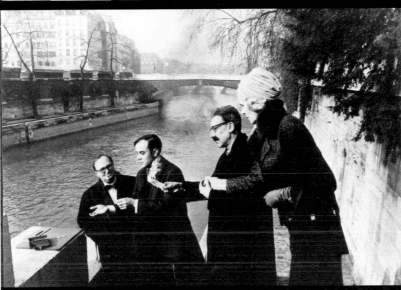

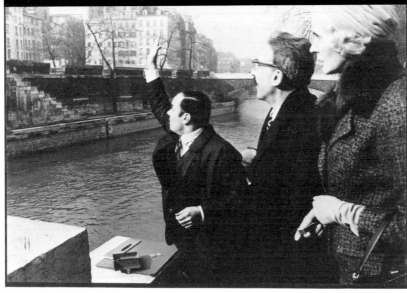

In 1962, the third adventure of "unreason" took place in Paris when Yves Klein, the French artist, proposed that I buy one of his "immaterials." This "work of art" was exactly what the word meant; in short, it didn't exist except as an experience which had no material substance.

At this time, Klein was known more for sensationalism than for his work as a serious artist. He was one of the organizers of the Paris group "New Realists," along with Arman, Tinguely, Niki de Saint-Phalle, and Christo. The scandal of Klein's reputation came from what he called *Anthropometries* or "body brushes." A nude female model would cover herself with blue paint, then he would direct the model to press herself against a sheet of white paper, which he affixed to canvas. The imprint of the torso comprised the finished work. Some of his other innovations were paintings with fire, and sponge sculpture. But his best-known work was done in a strong, deep, velvety monochromatic pure-pigment blue with what appeared to be silvery splinters of metal embedded in it. He called it IKB, International Klein Blue. No other blue on any other modern painting could be mistaken for it.

Before the tragedy of his death at 34, his reputation had become firm, not only in Europe but in the United States as well. His influence survives among many young artists.

I had heard about Klein's "immaterials" from another collector, Virginia Dwan, at whose gallery in Los Angeles I had first met Yves Klein and Rotraut, his German-born wife. Thus, when I agreed to buy one, I had some inkling, but not more, of what one did. First, I had to buy 160 grams of pure gold in sixteen ingots. Then it was arranged for us to meet at the Seine near the Pont Neuf at eleven o'clock in the morning. It was February 2, 1962. When my wife and I arrived, we found Yves, his wife, and several witnesses, among them François Matthey of the Louvre, Madame Bordeaux Le Pecq of the Musée d'Art Moderne, Virginia Dwan, and Pierre Descarques, the critic. Klein directed me to take half the ingots from the box which held them. I was tense; my body, taut. The eight ingots seemed very heavy in my hand. I looked at Klein; his face was young and his neatly combed hair was only slightly touched by the breeze. His eyes left mine and were studying the river and the sky. Next to me was my wife, wearing a grey velvet turban and a fur scarf around her neck. The sun was bright and the day was not as cold as it ought to have been for February.

"Now," Klein said in a low voice, "throw the gold pieces into the river."

At this point, I'm not sure how long I hesitated. The act of literally throwing money away was not consonant with either my upbringing or my character. Nevertheless, I felt a wave of exaltation and with it a kind of creativity which I had experienced before only a few times while writing. It was a sensation of being outside my body, not completely myself; a paradox of taking in more than I gave out.

Slowly, my hand lifted itself high in order to reach the Seine some yards away, and in a surge of ecstasy I threw the gold pieces toward the river. I followed the course of their rise, shining in the sun and then disappearing with modest splashes in the water. I felt purged; it was as if I had flown with them, leaving behind the baggage of daily living.

I was recalled by the sound of Klein's words which I couldn't make out. He handed me a sheet of paper and asked me to read it. It was the bill of sale.

"What do you want to do with it?" he asked.

My impulse was to fold it and put it away, but a look of intense expectancy in Klein's eyes held me back.

"Since this is an 'immaterial,'" I murmured, "Let's keep it that way."

I fumbled in my pocket for a match. Before I could light one, he had one of his own lit and handed it to me. I laid it against one corner of the sheet of paper. Silently, we all watched the contract turn to ash, and as it floated up, Klein pushed it toward the river. That seemed part of the ritual. The ashes disappeared, and for a moment we were silent. The *Zone of Immaterial Pictorial Sensitivity,* as Klein called the event, was mine as long as I live.

I must add that I've had no other experience in art equal to the depth of feeling of this one. It evoked in me a shock of self-recognition and an explosion of awareness of time and space.

When other works of art, material and dimensional, have become vague in memory, this immaterial construction of Klein's remains absolutely clear. Why not? I was also the artist that day. The act was as much mine as Klein's.

Eighteen months later we were at home in Los Angeles waiting for the arrival of Jules Langsner, the art critic, who had called to say he had something to show us.

Langsner had just come from Tokyo where, he told us, he had seen a memorial retrospective of Klein's work. In one of the rooms was a wall of enlarged photos of us standing on the bank of the Seine with me caught in the act of throwing the gold pieces into the river. Alongside were Dorothy, Yves, and the witnesses. This was the first time I knew that Klein had arranged to have a photographer nearby. I confess I felt let down. An "immaterial," I thought, should be altogether immaterial. The making of a film record seemed to be a corruption of the artist's intent as well as of the sensation of purity which had possessed me at that time. But later vanity came to the surface to appease me. The same photos were shown at The Tate Gallery in London, and will be again with Klein's retrospective in Houston, in New York at The Guggenheim, and finishing up at the Beaubourg, Paris. To have one's phiz hanging on such notable walls isn't so painful.

What *is* painful is our "chamber of horrors," a spare room filled almost to the ceiling with works we have bought but can't hang all at the same time. The "horror" does not reflect our view of the works there, including Rauschenberg's *Cardbirds,* an Oldenburg watercolor, and other equally worthy pieces. On the contrary, we look in there with dismay and apology that our appetites exceeded our wall space. Yet knowing what awaits any new acquisition, we cannot prevail on ourselves to cry halt. We are addicts, and we are beyond cure.

What, then, has it all added up to, these twenty-five years of immersion in the waters of contemporary art? There is the pride of ownership; the slight bubbles of pleasure that float up when this or that museum requests a loan; the joy of remembering the hundred incidents of discovery and the many accidents that led to them; the hours of exchanging talk with such artists as Willem de Kooning, Louise Nevelson, Esteban Vicente, Philip Guston, R. B. Kitaj, David Hockney, Robert Graham, Ed Kienholz, Billy Al Bengston, June Wayne, Arnold Mesches, Richard Diebenkorn, and others.

Even more important: What did it mean to live with the paintings and drawings surrounding us for years like magic casements? At first, they were a delight and a provocation. Some remained that way. Others we began to take for granted; they had been passed by and seen too often. Then one day, some of those that seemed to have worn off their welcome suddenly bloomed again, and a new wave of discovery commenced with new meanings (and our feelings) that had lain there all the time just out of reach. The excitement started over again.

With all this, there is something here of even greater significance than the collecting and enjoyment of art. In the thirties, I shared with my generation a meaningful effort to alleviate social distress. Thirty years later, I committed myself to still another kind of radicalism, that of the artists, militants who in their way opened our eyes to new ways of sensing the world around us and who brought a kind of leavening into troubled and anxious years.

We are still looking and seeing the younger ones who are themselves looking and seeing. We are indeed grateful that these experiences have helped make us more aware of the possibilities of life, but gratitude isn't enough; there is a debt to be paid. We hope that by giving back to the public through the Los Angeles County Museum of Art these works which we now own temporarily, we are partially taking care of that debt.

MICHAEL BLANKFORT
July 1981

CATALOGUE

These symbols appear on the following pages:

† *indicates image area measurements*

• *indicates works of art that are not part of the Blankfort bequest to the Museum*

Height precedes width in all dimensions given.

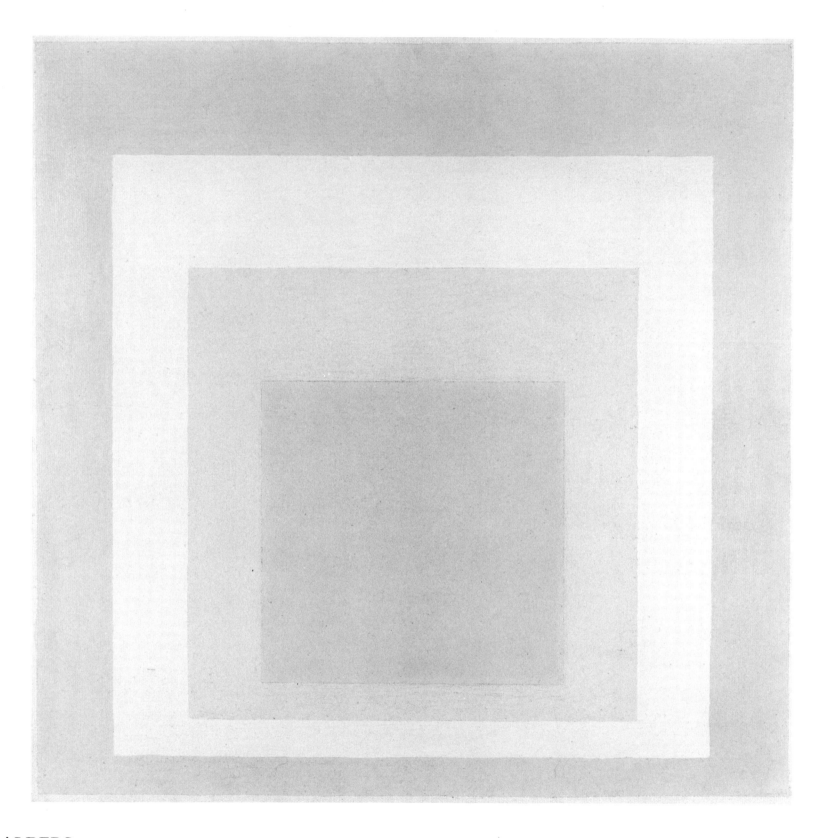

ALBERS

1. *Homage to the Square: Yellow Echo,* 1956
 Oil on canvas on board
 30 x 30 in. (76.2 x 76.2 cm.)

JOSEF ALBERS

American, b. Germany, 1888–1976

In science one plus one is always two, in art it can be three, or more.★

JOSEF ALBERS

The infinite range of chromatic possibilities—the relativity and instability of color—is the theme of Albers' immense series *Homage to the Square,* which consists of hundreds of paintings, and culminates in the artist's 1963 publication, *The Interaction of Color* (Yale University Press). Albers wrote that "color deceives continually," and set problems for his students to illustrate this fact. At Black Mountain College, Yale University, and many other American art schools, he emphasized dedication, seriousness, and discipline. His distaste for the Abstract Expressionist movement lay in his belief that its thinking tended to make students "sloppy and willful."

Albers was an artist of enormous productivity who prided himself on his few imitators, less from a desire to be inimitable than from his desire to foster "generations of artists . . . secure in individuality." His renunciation of critic William C. Seitz' association of him with the Op Art movement was, in Albers' words, because: "To distinguish any art as optical is just as meaningless as to call some music acoustical or some sculpture haptic . . . Such art terms are as redundant and nonsensical as wood carpenting or foot walking . . . or color painting . . . Visual perception presupposes optics . . . From here on, all following susceptivity . . . is psychological."

In the *Homage to the Square* works, oil paint is thinly applied to the prepared surface with a palette knife, usually directly from the tube. The hand of the artist, and any expressive gesture which might interfere with the pristine surface and the chromatic interplay, is virtually eliminated. Every painting in the series consists of an arrangement of three or four nested squares. Since the color of the squares is the only element that varies, the primary purpose of the series is to study, through varied juxtapositions, the influence that colors of differing hues and intensities have on each other. Albers methodically recorded on the back of every painting in the series the name and manufacturer of each color employed. Some titles refer to the colors' intrinsic properties, some to the forces of nature, while some imply the capability of action, as in *Yellow Echo.*

Albers' systematic study of color (and, in other series, of line) within severely restricted boundaries is of incalculable importance to contemporary American art, echoing in the work of Color Field painters, Geometric Abstractionists, Serialists, and Minimalists. Despite his disciplined, austere approach, Albers was not a scientist or theorist: ". . . science aims at solving the problems of life, whereas art depends on unsolved problems." Rather, Albers said, "my painting is meditative, is restful. . . . I seek no quick effects. . . . You see, this is what I want to create: meditation pictures of the twentieth century." *Homage to the Square: Yellow Echo* (1956) is such a poetic meditation.

Yellow Echo joins four others from the series in the Museum's collection, one acquired in 1953, and three as the recent gift of the Anni Albers Foundation.

★Spies, Werner, *Albers,* trans. Herma Plummer, New York, Harry N. Abrams, Inc., 1970, frontispiece.

2. *White and White,* 1973
 Oil on canvas
 28 x 28⅛ in. (71.1 x 71.4 cm.)

JOHN **ALTOON**

American, 1925–1969

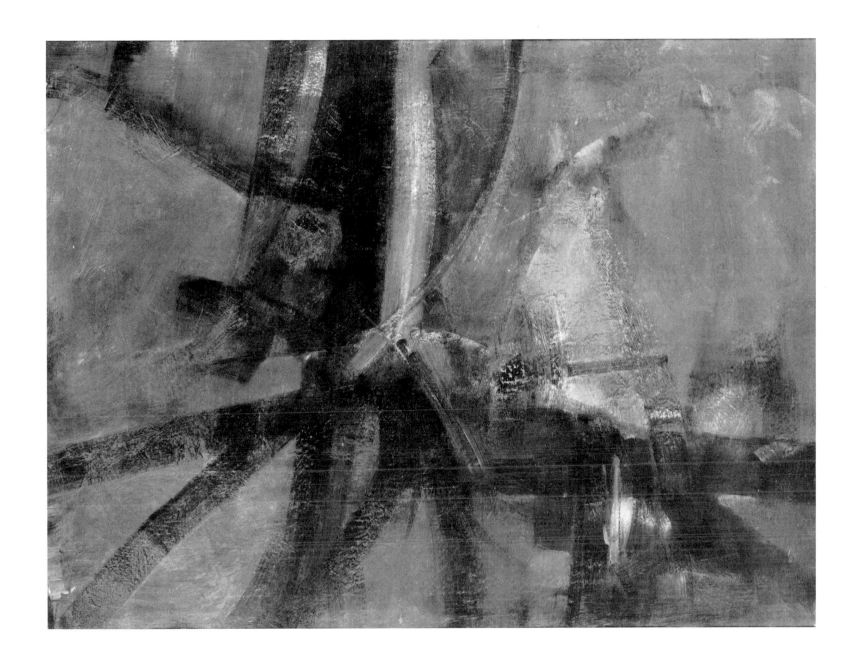

4. *Untitled*, 1955
 Oil on canvas
 34¹⁄₁₆ x 44⁷⁄₈ in. (86.5 x 114 cm.)

[Altoon] seemed to care little for ease and fortune. His habitat was the studio. The floors were covered in old canvases used as rugs. The smell was india ink and turpentine. There was always something new on the easel, and Altoon would be standing in the middle of all the mess in sandals and cut-offs petting his dog Man. It was a good time and place to be and I wish the fucker hadn't gone off and died. I still miss him.★

EDWARD KIENHOLZ

Best known for his erotic/ironic mature drawings, and for his role as a founding member of Ed Kienholz' and Walter Hopps' Ferus Gallery in Los Angeles, John Altoon is represented in the Blankfort Collection by an early work in the Abstract Expressionist style.

Of Armenian extraction, Altoon grew up in Los Angeles, fought in the Pacific during World War II, and returned to study at Otis and Chouinard art institutes. His skill as a draftsman led to early success in commercial illustration, but also created a conflict with his desire to become a serious artist. Indeed, emotional conflict plagued this passionate man, who was energetic and humorous, and a merciless self-critic; he edited and destroyed many of his works, breaking into the Ferus one night to destroy his own exhibition.

Altoon spent four years in New York in the early fifties, where he found a natural affinity with the spontaneous expression of Pollock, de Kooning, Rothko, and Kline. He exhibited at the Ferus alongside the northern California Abstract Expressionists Hassel Smith, Frank Lobdell, and Richard Diebenkorn, and the Los Angeles-based Richards Ruben.

Altoon's mature style combined his fluid, calligraphic line with delicate air-brushed color in daringly balanced abstract compositions, and in parodies of commercialism and the stereotypes of contemporary American life. In some series, the drawing attains a Rococo-like delicacy.

The Blankfort oil enriches the Museum's Altoon holdings, which include three oils, several drawings—some edited by Altoon and invaluable for study purposes—and numerous prints.

★Barton, Brigid S., *John Altoon,* exh. cat., De Saisset Museum, University of Santa Clara, California, 1980, p. 15.

ALTOON

AVIGDOR **ARIKHA**

Israeli, b. Rumania, 1929

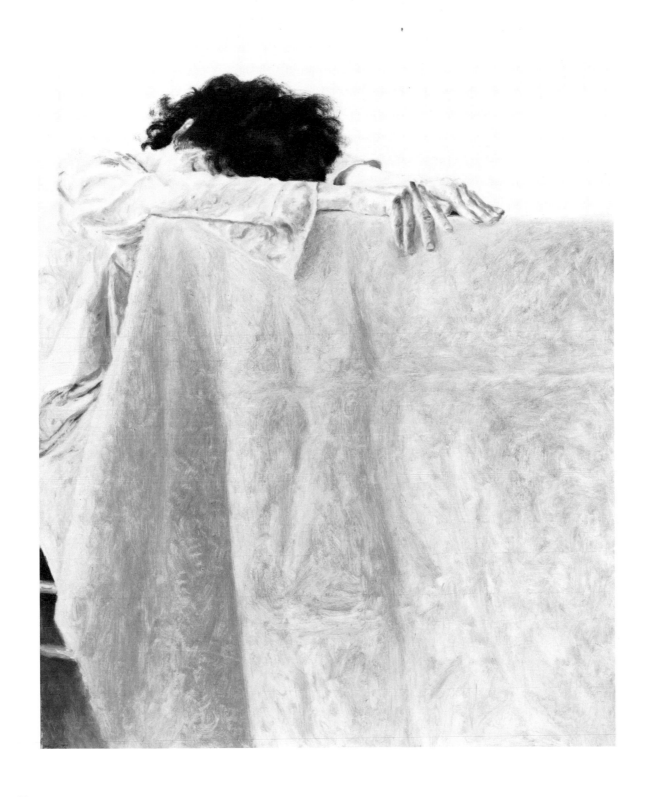

7. *Anne Leaning on a Table,* 1977
 Oil on canvas
 51³/₁₆ x 38³/₁₆ in. (130 x 97 cm.)
 M.79.153

Since I was taken by this hunger in the eye, . . . I submitted to strict observation . . . as I get closer and closer to what I truly see, the truer the painting becomes. . . . The relationships . . . unfold in an absolutely unpredictable way . . . in a logic that I grasp in the course of painting, increasing my state of intensity. . . . the lack of such a state . . . will inevitably bring about failure. Hence the small number of my works.★

AVIGDOR ARIKHA

A traditional painter, reverent of the integrity of his materials and his craft, Avigdor Arikha paints every one of his canvases in a single sitting. In this way he avoids the intrusion of any effects which would destroy the immediacy of his vision. He renounces working from photographs or from other paintings, remarking that "style grows from within." Observing the "recurrent confusion" that occurs in periods of stylistic change, he notes that "Doubt sets in. . . . what may appear to the future to be a change in orientation is actually felt by the solitary artist as a disoriented path. His step is in darkness."

The everyday objects of his surroundings—a worn shoe, a shelf of books, his wife, his own visage examining itself from behind a canvas—are the subjects of his work, since the subject is only an "excuse for making a painting."

Cézanne was an important early influence, and it is paradoxical how strongly Arikha's chalky palette evokes the black palette of some of the early works of Cézanne. *Anne Leaning on a Table* (1977) was a 1979 gift of the Blankforts to the Museum (the first American museum to exhibit Arikha's work). In the artist's own estimation, this is one of his most successful paintings.

The austerely beautiful composition depicts not only what is seen, but also what is felt, by creating the shimmering atmosphere of an electrically charged field.

Self-Portrait with Open Mouth (1973) displays the same immediacy of observation, purity, and honesty of vision. The Museum owns numerous prints and two books of etchings by Arikha.

★Livingston, Jane, *Avigdor Arikha: Twenty-two Paintings*, exh. cat., Corcoran Gallery of Art, Washington, D.C., 1979, unpaginated.

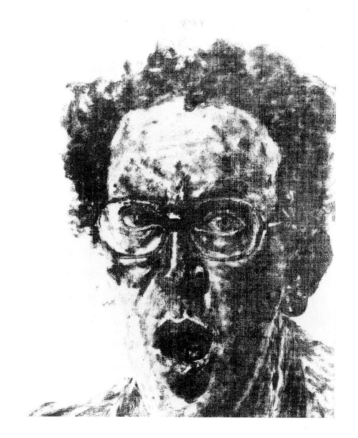

ARIKHA

6. *Self-Portrait with Open Mouth,* 1973
Aquatint 4/20
10¹³/₁₆ x 9⁷/₁₆ in. (27.5 x 24 cm.)†

MILTON AVERY

American, 1893–1965

[His subjects were] his living room; Central Park; his wife, Sally; his daughter, March; the beaches and mountains where they summered; cows, fish heads, the flight of birds; his friends and whatever world strayed through his studio: a domestic, unheroic cast. ★

MARK ROTHKO

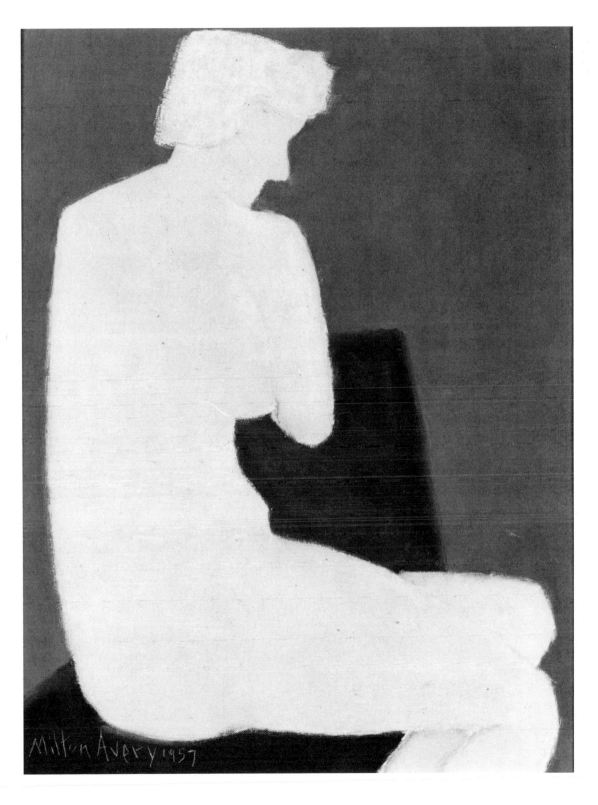

Mark Rothko, Milton Avery's friend, spoke these words at a memorial address in Avery's honor at the Brooklyn Museum in 1970. Avery was a master of figure painting. His forms suggest the broadness and simplicity of Matisse, and, like Matisse, he used color expressively. In *Seated Nude,* the pale pink figure against the rich magenta ground creates a poetic harmony punctuated by the black chair. The contour of the simplified, flattened figure reflects the confines of the picture space and forms an elegant surface pattern. Despite the lack of modulation, the mass and weight of the seated woman are persuasive.

Avery's later work, such as *Seated Nude* (1957), became relatively abstract, and was an important link between the late work of Matisse and the American Color Field painters. On the other hand, his maintenance of sympathy with European modernism throughout the forties and fifties was important in effecting the emergence of more recent realist movements.

★Rothko, Mark, "Commemorative Essay," (Memorial Address delivered at The New York Society for Ethical Culture on January 7, 1965), in *Milton Avery—Prints and Drawings: 1930–1964,* exh. cat., Brooklyn Museum, 1966, p. 16.

• 9. *Seated Nude,* 1957
 Oil on board
 15 7/16 x 11 5/16 in. (39.2 x 28.7 cm.)†

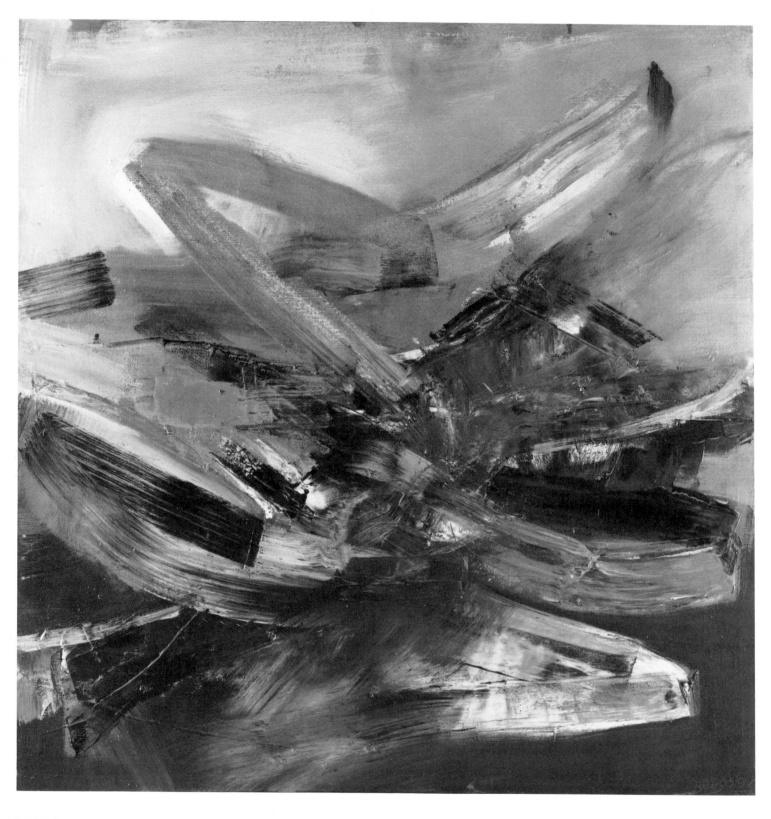

BENGSTON

10. *Untitled*, 1957
Oil on canvas
33½ x 32⅛ in. (85.1 x 81.6 cm.)

BILLY AL BENGSTON

American, b. 1934

*I started doing [the chevrons] arbitrarily, for no reason—which is a nice reason to start doing something. But it's also one of the reasons that an abstract painting...can't be talked about. ...it's a hell of a lot more interesting to talk about something you can't talk about...it's every bit as reasonable as talking about angels.**

BILLY AL BENGSTON

Billy Al Bengston's influential career in Los Angeles spans more than two decades, during which he has produced a body of work of strength and originality. His best-known series are marked by the use of signature emblems: the cross, iris, heart, or chevron.

Bengston graduated from Manual Arts High School, studied at Los Angeles City College, the California College of Arts and Crafts (under Richard Diebenkorn and Sabro Hasegawa), and at Otis Art Institute (under Peter Voulkos). At the latter two institutions his experience with ceramic media and with associated oriental techniques and attitudes has informed both his imagery (in the centered emblems) and the meditative, icon-like quality of much of his work.

His essentially ceramic aesthetic has been translated into painting through the vehicle of nontraditional painting media, using aluminum and Masonite as support with sprayed synthetic lacquer and polymer as pigment. Bengston's use of these materials undoubtedly arose from his experience of racing and painting motorcycles, and parallels other Los Angeles artists' use of modern technology and materials. His acquaintance with the work of Jasper Johns is also acknowledged as important in the development of his centered compositions.

The untitled 1957 oil was exhibited in Bengston's first show at the Ferus Gallery. The work is in the Abstract Expressionist style—then emanating from New York—which characterizes the early work of many artists who came to maturity in the sixties. *Untitled* (Cannes) of 1958 belongs to a lesser-known body of late-fifties work which combines drawing with torn paper and flecks of paint.

The centered chevron of *I Tatti* (1961) flickers in and out of view beneath sprayed layers of magenta lacquer. The personal scale of this piece—some chevron paintings are as large as six by seven feet—enhances its spirituality, inviting the viewer to become more than momentarily involved, and to experience the simultaneously fugitive and constant image. The absence of any contextual reference evocative of the expected military associations of the chevron makes the piece enigmatic and open to individual interpretation.

Sheet aluminum—folded, crimped, and articulated with repoussé lines—forms the ground for Bengston's *Canto Indento* series, of which the untitled work of about 1968 is a part. In the larger works of this series, after preparation of the metal, the surface was carefully masked and the chevron emblem sprayed with synthetic automobile lacquer. In this example, the pink lacquer was silk screened on and interacts with the opalescent oxidation and the shifting reflected light of the surface to create surprisingly delicate effects.

Four of the Blankfort Bengstons will join numerous prints and three other works in mixed media by this artist, including the major work *Hatari* of 1968, in the Museum's collection.

*Robinson, William A., "Bengston, Grieger, Goode: 3 Interviews," *Art in America,* vol. 61, no. 2, March–April 1973, p. 48.

11. *Untitled* (Cannes), 1958
 Collage with ink and watercolor
 12⅜ x 9½ in. (31.4 x 24.1 cm.)

12. *I Tatti,* 1961
 Oil and lacquer on board
 14 x 14 in. (35.5 x 35.5 cm.)

BENGSTON

13. *Untitled*, c. 1968
 Lacquer on aluminum
 24 x 22 in. (61 x 55.9 cm.)

• 14. *Untitled* (Lahaina series), 1978
 Watercolor
 12 x 10⅝ in. (30.5 x 27 cm.)†

TONY BERLANT

American, b. 1941

I want my work to be as intense, as vague, as beautiful, and as ugly as life itself. I want an art that projects an intensified and clarified vision of the way things are. . . .★

TONY BERLANT

Berlant's work over the past twenty years has evolved through a sequence of highly individual expressions, utilizing an enormous range of materials. He alternates between figurative and non-figurative modes, and has employed such diverse materials as sheet aluminum nailed over wood and fragile, appliquéd silk. Berlant has also dealt with a wide range of subject matter. *Elegy for Chicken Little* (1963) is pure fantasy; according to the artist, "nothing is meant by the title." A seventies sculpture series, *The Marriage of New York and Athens,* is conceptual. The recent series, *Remembrances,* attempts by evocation to capture the "subjective matter" of a loved person or animal.

Rainbo and *Elegy for Chicken Little* were both made in 1963 and show that the artist works in radically different techniques and media at the same time. *Elegy for Chicken Little* is an assemblage of feathers, fabrics, and "software"; *Rainbo* is a "hardware" assemblage of painted and rusted metals nailed to wood. This versatility has characterized all of this artist's production to the present time.

Berlant was a student at the University of California, Los Angeles, at the time that several of the Blankfort pictures were on long-term loan there (including de Kooning's *Montauk Highway* and Gorky's untitled study for *The Calendars*). Hal Glicksman of Otis Art Institute, also a student at UCLA at that time, has remarked on the importance of those pictures to the art students then at UCLA.

The Museum owns another painting of the *Elegy for Chicken Little* series, as well as three other works by Berlant.

★Turnbull, Betty, *Tony Berlant,* Newport Harbor Art Museum, Newport Beach, California, 1978, unpaginated.

15. *Rainbo,* 1963
Metal collage
9¾ x 10 in. (24.8 x 25.3 cm.)

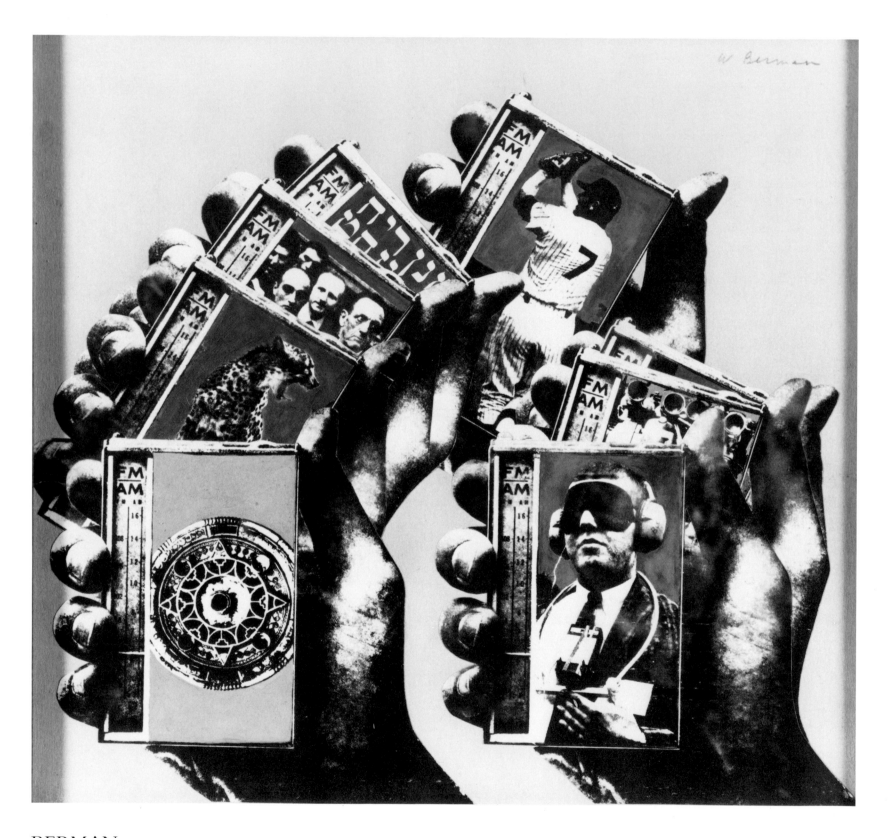

BERMAN

17. *Untitled*, 1968
Verifax collage and paint
$10^{13}/_{16}$ x $11^{3}/_{4}$ in. (27.5 x 29.8 cm.)†

WALLACE BERMAN

American, 1926–1976

I'm letting it come through from dead Poets.
WALLACE BERMAN

A tragic automobile accident in 1976 cut short the life and career of Wallace Berman, acknowledged (with Ed Kienholz) as the inventor of the California assemblage movement. His subject matter is esoteric and intensely private, but evokes profound associations in the viewer, whether or not he or she fully understands its multivalent references.

Berman shunned publicity during his lifetime and destroyed many of his works; he gave much of his art away to friends. During an exhibition at the Ferus Gallery in 1957, he was arrested for a sexually explicit image included in the collage *Factum Fidei* (1956). He turned to hand-printing his *Semina* series albums to avoid the censorship restrictions to which commercial printers are subject.

His imagery has been associated with the Cabala, Tarot, and I Ching, as well as with mysticism of all kinds. His reverence for the work of Hermann Hesse, reflected in *Homage to Hesse* (1949–54), does much to explain the complexity of his iconography. In particular, Berman was fascinated by Hesse's last book, *Magister Ludi (The Glass Bead Game),* whose title and meaning derive from the Latin *lūdicrus* (sportive) and *lūdicrum* (public games), but which is also the root of our English word "ludicrous," connoting the absurd.

Untitled (1968) belongs to Berman's last series of collages. In these works, the repeated image of the artist's hand holding a tiny portable radio was reproduced on a Verifax machine. The radios display images from art, archaeology, religion, the natural world, and famous figures from contemporary news media. In the Blankfort collage, financier Norton Simon shares the field with a baseball player, a gold brooch of pagan Anglo-Saxon date, a cheetah, a fragmentary

Hebraic inscription, and the keys of a woodwind instrument. The blindfolded figure at the lower right appears to receive a message contained in the juxtaposed images. The artist, personified by the radio, acts as a conduit through which signals from the cosmos may be revealed. In many of Berman's Verifax collages the hands are arranged in compartmented rows on a black field. Here, the composition arcs across a field of brilliant color, suggesting the form of a hand of cards, and referring to the element of chance that takes place when cards are shuffled and dealt.

The Museum owns two other works by Wallace Berman.

★Wallace Berman: Retrospective, exh. cat., Otis Art Institute Gallery, Los Angeles, California, 1978, p. 9 (interview with Walter Hopps).

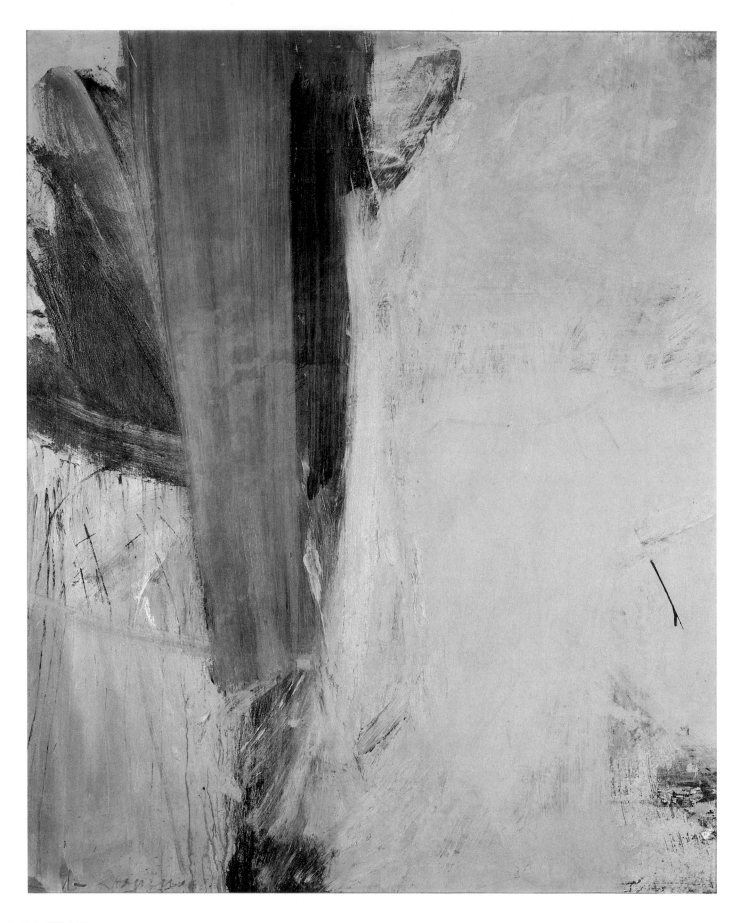

DE KOONING

31. *Montauk Highway,* 1958
Oil on canvas
59 x 48 in. (149.8 x 121.9 cm.)

WILLEM DE KOONING

American, b. Holland, 1904

It's a very free interpretation...to sit in a car and move, it would be very much like that—going and passing things.★

WILLEM DE KOONING
(on Montauk Highway)

The flash of headlights on the roadside in darkness is the image evoked by de Kooning's *Montauk Highway.* According to Hal Glicksman of Otis Art Institute, this painting exerted a powerful influence upon him and other art students at UCLA in the late fifties when it was on long-term loan there from the Blankforts. The picture records an impression of de Kooning's surroundings during the months he rented Conrad Marca-Relli's home on Fireplace Road, in Springs, near East Hampton, New York.

The de Koonings had been spending summers—and then longer periods—in East Hampton since 1948. They were accompanied by the Jackson Pollocks and dealer Charles Egan on their first trip; they were guests of Leo Castelli in 1952 and 1953; in 1954 de Kooning and Franz Kline had adjacent studios. In 1962, de Kooning became an American citizen and began to build his Springs studio. *Springs Hollow* (1965) and the untitled 1970 oil on newsprint reflect the artist's impressions of his home. The delicate pink, blue, and chartreuse are characteristic of these pictures of the Long Island countryside.

"I wanted to get in touch with nature, not painting scenes from nature, but to get a feeling of that light was very appealing to me.... When I came here... I had three pots of different lights... one was lighting up the grass.... One was lighting up the water.... It was like the reflection of light."

The two 1962 *Woman Study* drawings reflect de Kooning's long struggle with this theme. While one is easily recognizable, the other is highly abstract, and may well have grown out of the softly brushed landscapes of this period. Of the *Woman* series de Kooning has said: "...People say I made such monsters. I don't think so at all."

In 1969, at the invitation of his friend Herzel Emmanuel, who had recently acquired a foundry, de Kooning began experimenting with sculpture. He closed his eyes, as he had begun to do in drawing in the mid-sixties, and worked very quickly. As he worked the clay, he experimented with wearing gloves of different sizes and textures. This factor had an expressive effect on the appearance of the clay models which were then cast into bronze. The 1970 *Figure V* is from this initial experiment, which led to a five-year interest in larger sculpture.

In place of the earlier importance of Cézanne, Picasso, and Braque reflected in *Man* (1947), which resembles drawings Picasso made of his friends in the Russian Ballet around 1920, de Kooning now seeks the freedom of Matisse. He plans a beach tableau of which he says: "It's not going to be easy....Just because you're getting old it doesn't mean you're getting any better. But I have a feeling I can do it better now."

Eight of the ten Blankfort de Koonings will join six other works by this master of American art in the Museum's collection.

★Wolfe, Judith, *Willem de Kooning,* exh. cat., Guild Hall of East Hampton, Inc., New York, 1981, pp. 11, 13.

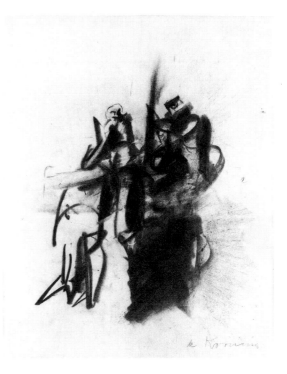

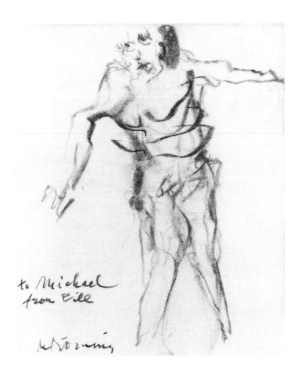

33. *Woman Study,* 1962
Charcoal
10⅞ x 8⅜ in. (27.6 x 21.2 cm.)†

• 34. *Untitled,* 1962 (inscribed "To Michael from Bill")
Charcoal
10 x 8 in. (25.4 x 20.2 cm.)†

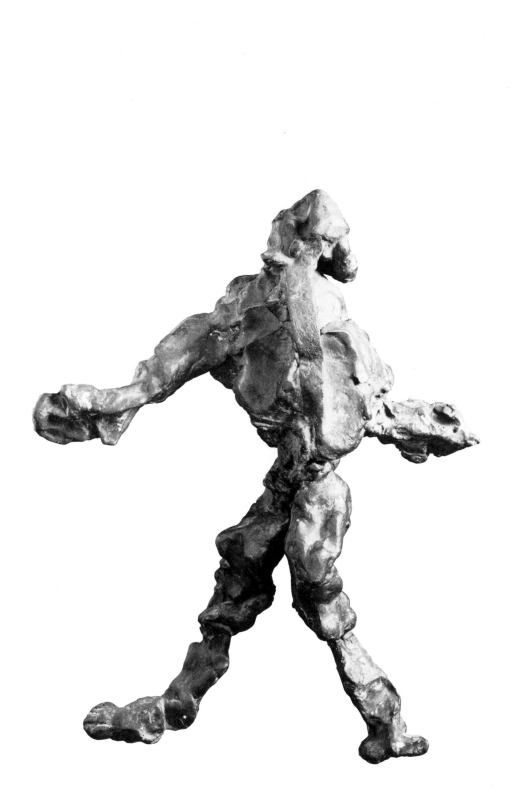

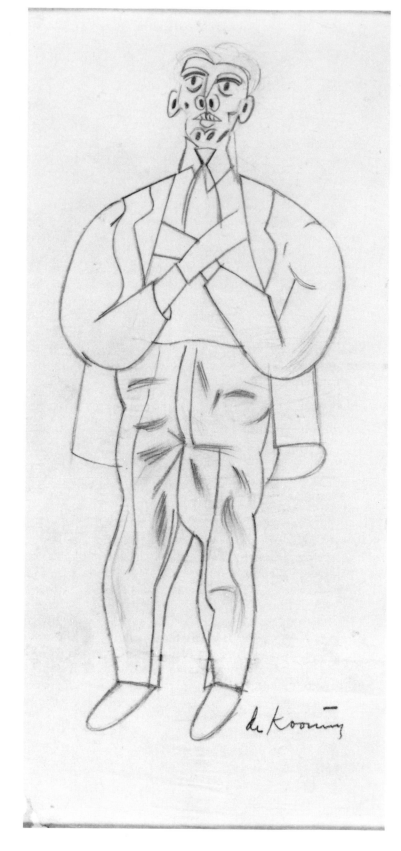

DE KOONING

37. *Figure V*, 1970
 Bronze 1/6
 14 x 10⅝ x 2¼ in. (35.6 x 27 x 5.7 cm.)

30. *Man*, c. 1947
 Pencil
 13¹¹/₁₆ x 6³/₁₆ in. (34.8 x 15.8 cm.)†

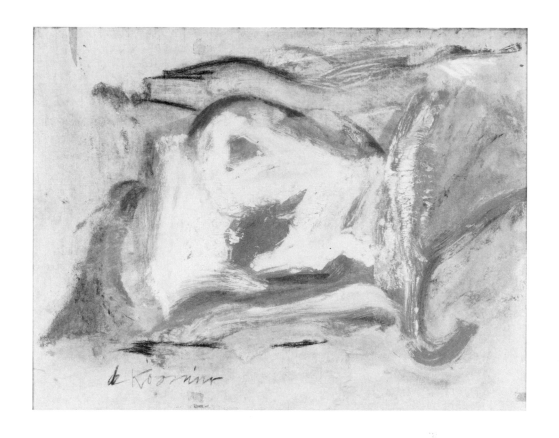

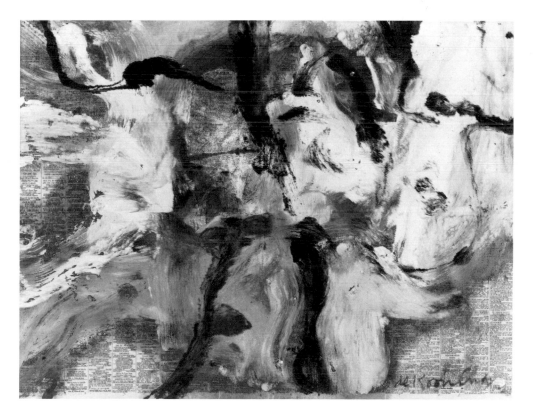

DE KOONING

35. *Springs Hollow,* 1965
 Oil on paper
 19 ½ x 24 ⅞ in. (49.5 x 63.2 cm.)

• 36. *Untitled,* c. 1970
 Oil on newsprint, mounted on linen
 22 ⅜ x 29 ¼ in. (56.8 x 74.3 cm.)

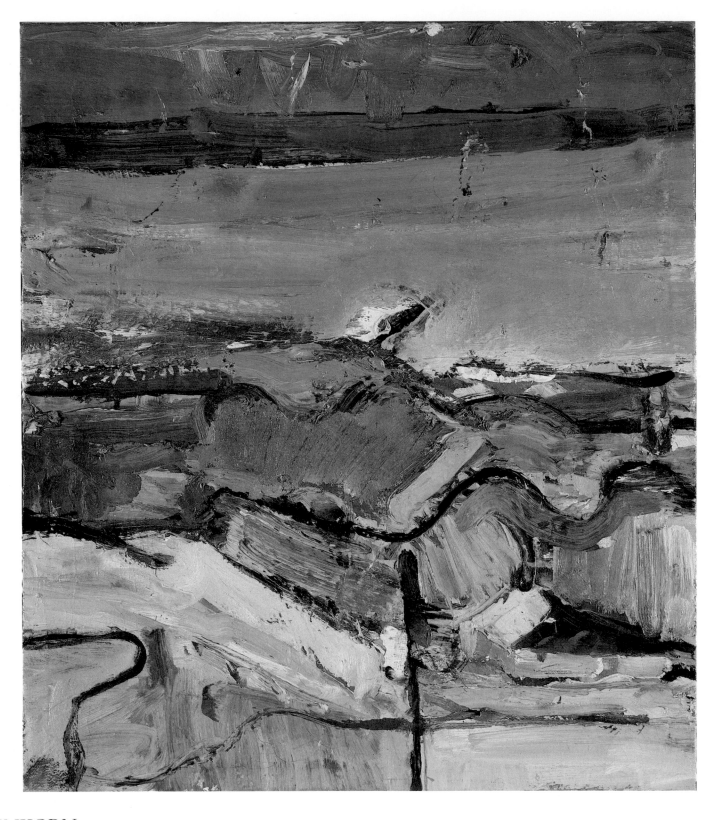

DIEBENKORN

42. *Berkeley,* 1955
Oil on canvas
24 x 21⅛ in. (61 x 53.6 cm.)

RICHARD DIEBENKORN

American, b. 1922

I'm really a traditional painter, not avant-garde at all. I wanted to follow a tradition and extend it.★

RICHARD DIEBENKORN

Diebenkorn has produced—and continues to produce—a body of work of transcendent beauty and originality squarely within the Western painting tradition. His mature style is comprised of several distinct periods, yet his radiant color, calligraphic line, and dynamic sense of structure unite the entire oeuvre.

Educated at Stanford and at the University of California, Berkeley, Diebenkorn studied at the California School of Fine Arts in San Francisco after military service in World War II. In 1950 he enrolled in the University of New Mexico where he earned his M.F.A. The Albuquerque paintings, the first distinct series following his years of study in San Francisco which concentrated on the banishment of figuration, admit elements from the landscape and local color, which are occasionally repeated in later works. Diebenkorn studied the Abstract Expressionists and is widely knowledgeable in Western art history. Matisse is probably his most powerful lifelong influence, for what Diebenkorn learned from him about color and about a sense of structure underlying flatness, expressed by the agile use of line.

Diebenkorn remained in New Mexico for one year after completion of his graduate work, then taught one year at Urbana, where he found the bleak Midwestern landscape uninspiring. He spent the following summer of 1953 in New York, where again the quality of life seemed to weigh on his spirit. The 1952 watercolor, previously called *Berkeley,* must belong to this period, both because its date (in the artist's hand) antedates his return to California, and because its density and aerial-map effect typifies the Urbana works.

In the fall Diebenkorn returned to California and set up his studio in Berkeley. The series of pictures that followed, extending through mid-1955, are named for this location. Their radiant color and openness reflect the artist's own soaring mood after his return to his native West.

The 1955 oil, with its lively blue, green, and orange color scheme, exhibits the tripartite banding which is an underlying feature of much of Diebenkorn's art, resulting from a persistent memory of the powerful Bayeaux Tapestry. The upper third is traversed by a shape reminiscent of a prominent bluff that had been visible from his New Mexico home, and which appears in many of the works from that earlier period.

The important drawing *Man and Window* of 1956 has been exhibited widely; it is one of the first of Diebenkorn's figural period, which lasted from 1956 to 1966–67 when he moved to Santa Monica and began painting the *Ocean Park* series.

The strength of Diebenkorn's work lies in his skilled synthesis of spontaneity with the evidence of his experimentation; the visual evidence of his exploration and discovery is preserved without losing the freshness of his vision.

The Blankfort gift of three Diebenkorns will substantially enlarge the Museum's holdings of one painting and nine prints by this artist.

★Tuchman, Maurice, "Diebenkorn's Early Years," *Richard Diebenkorn: Paintings and Drawings, 1943–1976,* exh. cat., Albright-Knox Art Gallery, Buffalo, New York, 1976, p. 13.

40. *Untitled,* 1952
Watercolor
13¾ x 12¼ in. (35 x 31.1 cm.)†

•41. *Untitled,* 1954
Watercolor, pencil, and crayon
12 x 9 in. (30.5 x 22.8 cm.)†

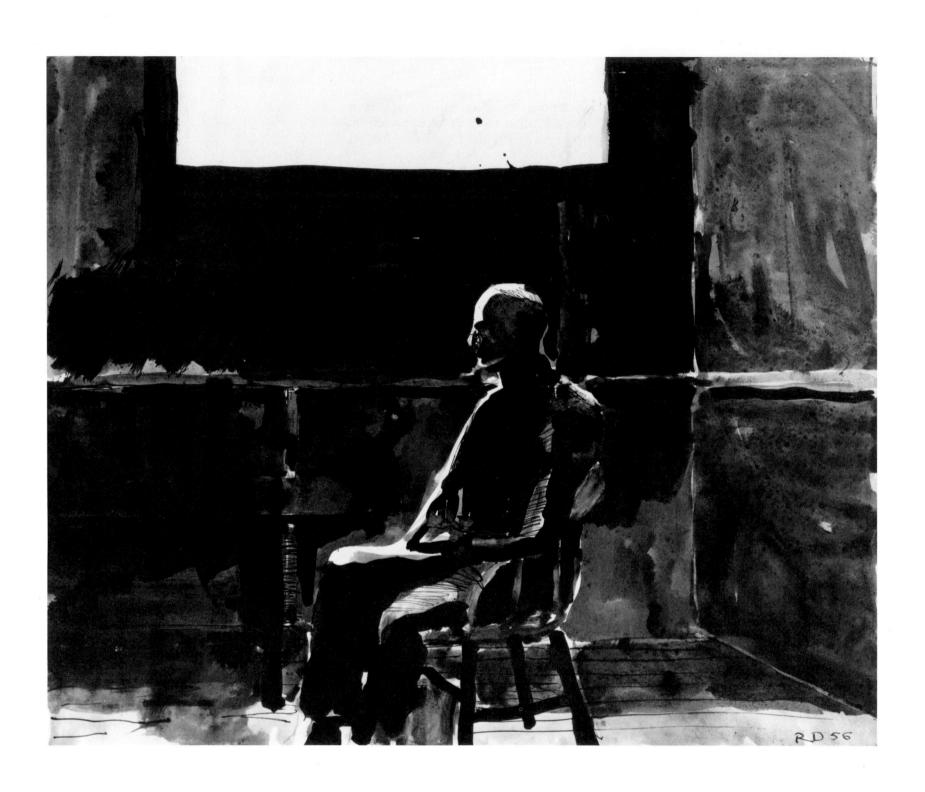

DIEBENKORN

43. *Man and Window*, 1956
Ink and watercolor
14 x 17 in. (35.5 x 43.2 cm.)†

JOE GOODE

American, b. 1937

I guess you might say that having picked up the Milk Bottles, come into the House and looked out the Window, I finally saw the Sky. I started doing drawings of the sky alone . . . there is nothing more ambiguous than the sky, or more typical.★

JOE GOODE

Goode refers, in the quotation above, to his early-sixties series of *Milk Bottle Paintings, House Paintings,* and *Window Paintings.* Their resemblance to Pop art imagery had caused him to be associated with that movement, though in his own estimation he was "certainly not a Pop artist," then or ever.

He began to achieve local recognition as a result of the 1961 *War Babies* exhibition at the short-lived Huysman Gallery. Goode had helped to conceive this exhibition to distinguish his generation from the slightly older Ferus Gallery group. He was included, along with other Los Angeles artists associated with the Pop art movement in California, in Pop art exhibitions of national importance.

Vandalism of 1973–74 is a part of the artist's *Torn Sky Paintings* series—pictures which represent a sky torn away in certain areas to reveal another sky. In this case the sky has been slashed, revealing the wood backing behind the canvas. These, and all of Goode's mature works, are concerned with illusion; the viewer's reflection in the glass or Plexiglas before the painted image is a part of the artist's intention. The banal subject matter is presented without literary context so that the viewer is left to form private associations.

The untitled oil on paper of about 1960–61 antedates Goode's mature style. The symbols appearing in the field are not intended to evoke any secondary meaning but are self-referential.

The Museum owns four other works by Joe Goode.

★Robinson, Wm. A., "Bengston, Grieger, Goode: 3 Interviews," *Art in America,* vol. 61, no. 2, March–April 1973, p. 52.

57. *Vandalism,* 1973–74
Oil on canvasboard
17¹¹/₁₆ x 23¹¹/₁₆ in. (44.9 x 60.2 cm.)†

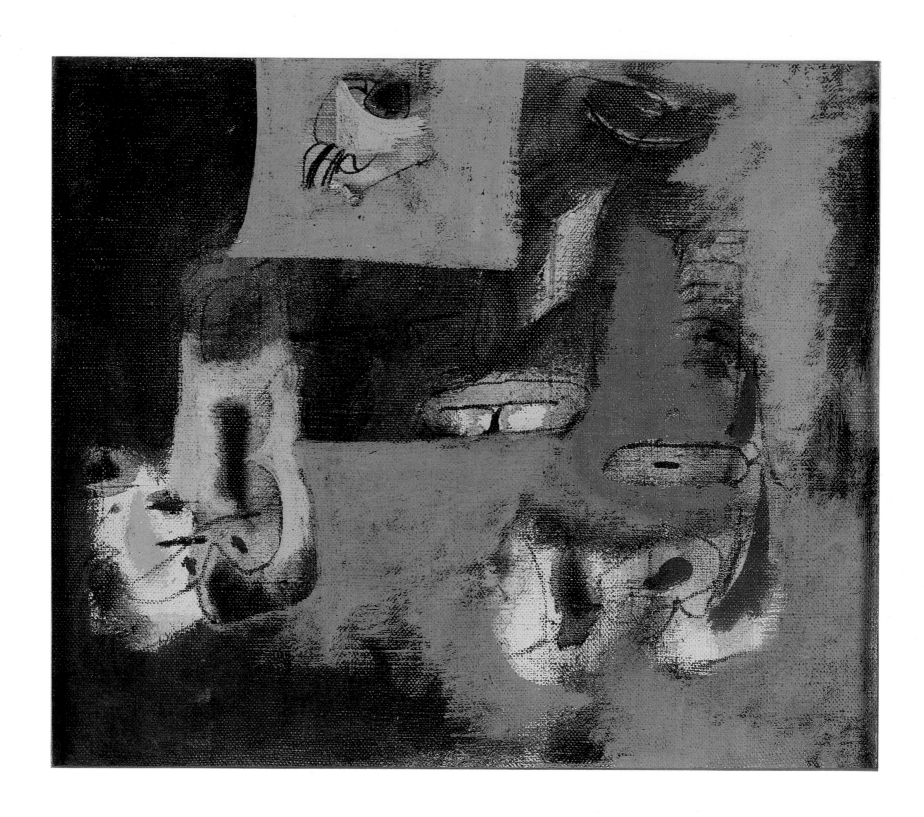

GORKY

60. *Untitled* (study for *The Calendars*), c. 1946
Oil on canvas
9⁵/₁₆ x 10³/₄ in. (23.7 x 27.3 cm.)

ARSHILE GORKY

American, b. Armenia, 1904–1948

Gorky stands revealed [through this study] as that rarest of creatures, a modern history painter; it was his own history that he painted.★

HARRY RAND

Arshile Gorky has been recognized for decades as one of the foremost innovators of the new American art that emerged after World War II in New York. The tragic enigma of his life was matched by the riddle of his iconography, only now yielding to reinterpretation.

Gorky was born Vosdanik Manuk Adoian in 1904 in Turkish Armenia. War and terrorism dispersed his family and Gorky was left at an early age to fend for himself. He arrived in America in 1920, and little is known about the next five years of his life; in 1925, however, he emerged in New York and took the name Arshile Gorky. Arshile is a variant of Achilles, and Gorky means "the bitter one" in Russian. Gorky claimed relationship to the famous writer Maxim Gorky, and fabricated for himself an aristocratic and darkly mysterious personality.

Tragedy of all kinds stalked his brief life: the breakup of his marriage to his first wife, Marny George; a frustrated but passionate relationship with a young woman named Michael West; the grinding poverty of the Depression; a disastrous studio fire that destroyed about twenty-seven paintings; cancer; an automobile accident that broke his neck and left his right arm—possibly temporarily—paralyzed; the departure of his beloved second wife, Agnes Magruder ("Mougouch"), and their two daughters. In July 1948, Gorky hanged himself in a woodshed near his Connecticut home. "Goodbye My Loveds" was written on a wall near his body.

Formalist criticism, which dominated the American scene throughout the fifties and sixties, saw Gorky's art as entirely abstract, pointing out the relationship to Surrealism. The relationship is indeed strong; Gorky, as one of the few who could converse with the Europeans, was an important link between the young Americans and the exiled French Surrealists in New York in the thirties. Recent study of the sketches and drawings, however, reveal the landscapes, interiors, and family members that surrounded the artist in his last years.

Untitled of about 1946, is a sketch for one of Gorky's masterpieces, *The Calendars,* which was destroyed by fire in 1961. The painting depicted an interior with a fireplace near the center of the composition. The artist stood at the right behind the figure of his wife in an armchair rocking their youngest daughter in a cradle. On the left, their older child sat in a wingbacked chair gazing out a window. The family dog lazed before the fire. Two calendars,★ which gave the painting its name, were hanging on the rear wall of the room. Not all of these elements are visible in the Blankfort sketch, but one of the calendars (a rectangle at the upper edge) and the two main figural groups (left and right) are present.

The untitled drawing of about 1947 explores one of Gorky's last four themes. The Museum's holdings of three early oils and one drawing by Gorky will be significantly enhanced by this gift.

★Rand, Harry, *Arshile Gorky: The Implications of Symbols,* Allenheld & Schram, Montclair, New Jersey, 1981, p. xx.

61. *Untitled,* c. 1947
Pencil and colored crayon
17⅛ x 23⅛ in. (43.5 x 58.7 cm.)†

GRAHAM

• 62. *Untitled,* 1975
 Porcelain, negative relief
 8⅝ x 10⅛ in. (21.9 x 25.6 cm.)

ROBERT GRAHAM

American, b. Mexico, 1938

It's like seeing them real close and yet really far away.★

> John Altoon, in conversation with
> *ROBERT GRAHAM*

The model stands on a revolving pedestal before the video camera and moves to fill the screen as sculptor Robert Graham studies every aspect of the form. Four months or more of such observations result in the painstakingly detailed clay and wax figure, which is then cast in bronze by the ancient lost-wax process. Each major work becomes a matrix figure to be utilized—in various scales, in whole or in fragment, in positive or negative relief—in Graham's compositional works. The sculptor works in relief on flat or columnar surfaces and in full-round figures.

The fine anatomical detail makes the figures powerfully believable; yet, at the same time, the sensuous surface treatment makes them extremely satisfying as objects whether the medium is bronze, sometimes gilded or painted, or porcelain. In relief or in the round, Graham's figures and fragments embody a quality of near-hallucinatory expectancy—a sense of emerging from mist or out of time—that gives them a beauty and significance beyond their intrinsic qualities as representation or craft.

★Tuchman, Maurice, *Gallery Six: Robert Graham,* Los Angeles County Museum of Art, 1981.

•63. *Untitled,* 1975
Gilded bronze relief 5/6
5⅞ x 3⅛ in. (14.9 x 7.9 cm.)

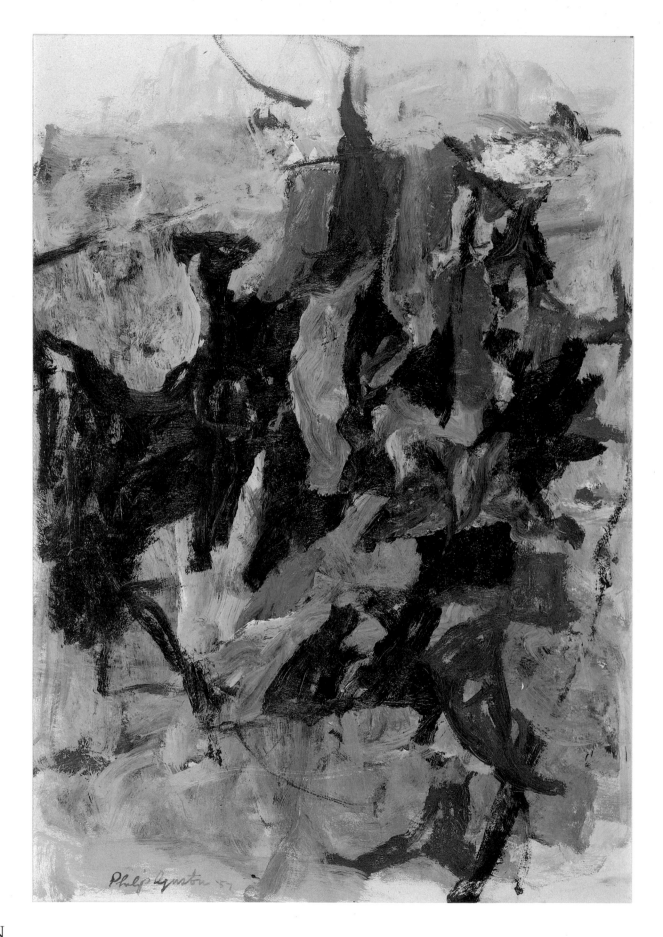

GUSTON

64. *Hester*, 1957
Oil on paper, mounted on board
35 ½ x 24¼ in. (90.2 x 62.2 cm.)

PHILIP GUSTON

American, b. Canada, 1913–1980

I got sick and tired of all that purity! I wanted to tell stories!★

PHILIP GUSTON

A leading Abstract Expressionist in the fifties, Philip Guston astounded his public in 1970 when he introduced a completely new iconographic repertory. His mature style of the fifties and sixties combined the energy and gestural qualities of de Kooning with the softness and lyricism of late Monet. He objected to the critical appellation of "Abstract Impressionist," but the lovely pinks and greys of the atmospheric *Hester* make this association understandable if not apt. *Hester* (1957) and *Mott III* (1958) are both in the abstract style for which Guston is best known.

Guston was born in Montreal of Russian immigrant parents who settled in Los Angeles when Philip was six. He was a classmate of Jackson Pollock at Manual Arts High School, and later attended Otis Art Institute where he became friends with Lorser Feitelson.

The unfolding of Guston's career in New York after his move there in 1936 paralleled that of the other major figures of his generation. Admiration for the Mexican muralists and mural-painting experience with the WPA combined with the influence of the many exiled European artists in New York to produce the monumental style which catapulted New York to the center of the art world.

Along with other artists of his generation who abandoned abstraction for figuration late in their careers, Guston dropped his abstract manner. The new style, reminiscent of some of the artist's favorite cartoons, but having autobiographical overtones which are both ominous and peculiarly poignant, occupied the last decade of his life. These last works, done in a style reminiscent of the work of comic-strip artist "Bud" Fisher, but executed with a painterly technique, are peopled with Ku Klux Klansmen, stacks of corpses, the nearly omnipresent smoking man, the disembodied eye of the painter, and the ubiquitous hobnailed boot.

Boots protrude from a stack of bodies, lie stacked in a cellar, or blossom from upright stalks like mysterious benthic flowers. The palette is Guston's own: salmon pink, orange, grey, green, and blue; the mood is distressing. Everything looks comical and gay, but something is not right. There is a sinister, dreamlike ambience.

Study for the Desert (1974) is a charcoal drawing in this late manner. It depicts a projecting hand flailing at a pile of hobnailed boots apparently stacked on a table. Because these elements appear without context, they seem able to transform themselves into cacti or into phallic forms and then back again into boots.

The Museum's collection contains one major oil in Guston's abstract style, *The Room* of 1954–55, as well as two other works by this artist.

★Hughes, Robert, "Ku Klux Komix," *Time,* November 9, 1970, p. 62.

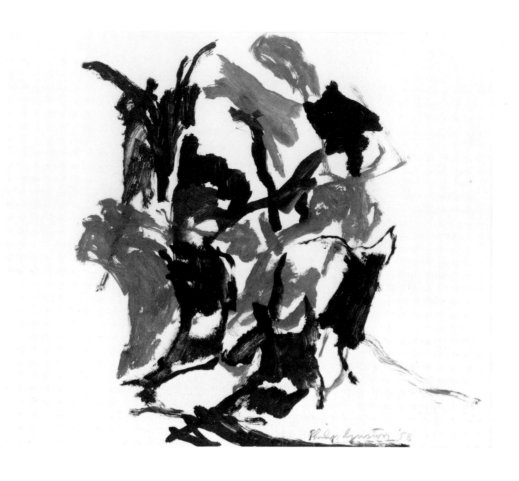

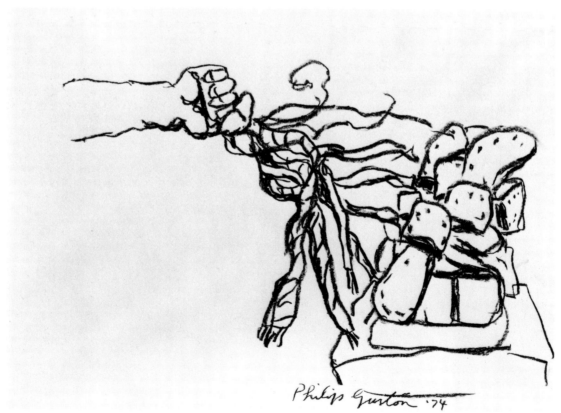

GUSTON

65. *Mott III,* 1958
 Oil on paper, mounted on board
 19⅝ x 24 in. (49.9 x 61 cm.)†

66. *Study for the Desert,* 1974
 Charcoal
 17¹⁵/₁₆ x 23⅜ in. (45.6 x 59.4 cm.)†

MAXWELL HENDLER

American, b. 1938

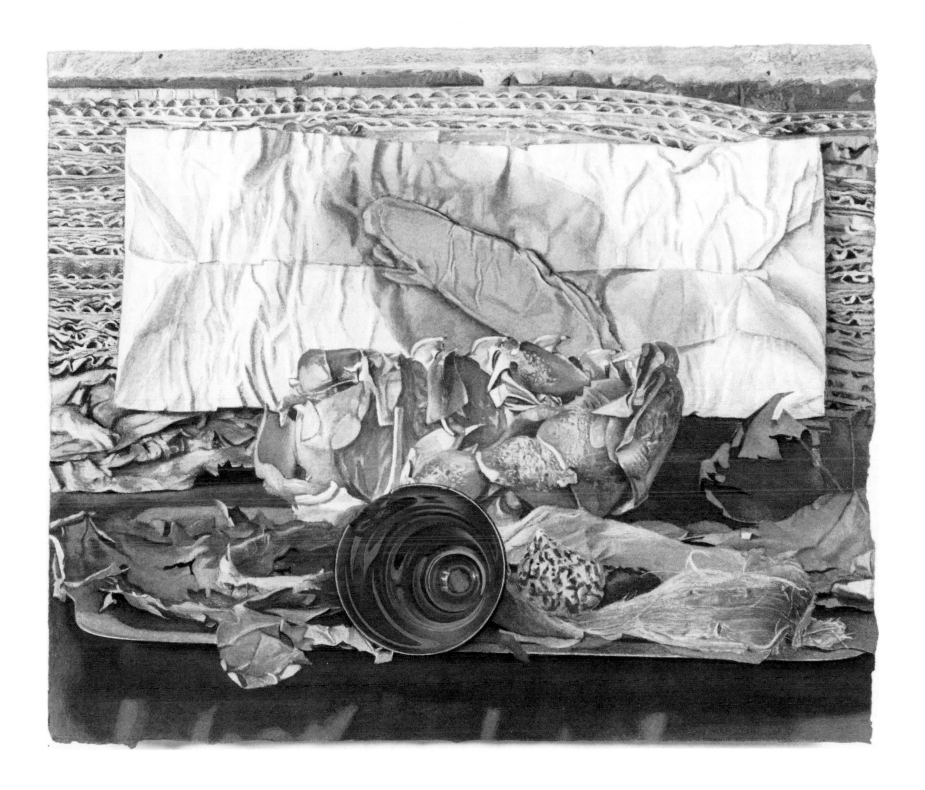

69. *Abnormal Subject Matter,* 1976
Watercolor
8 x 9⁵/₁₆ in. (20.3 x 23.7 cm.)

GEORGE HERMS

American, b. 1935

In a complete assemblage environment of his own making, and in close association with a group of poets and artists (notably Wallace Berman), George Herms evolved his version of the California assemblage style. Herms is largely self-taught as an artist, and his work is less personal than the covert language of Berman and less socio-political/critical than that of Kienholz. Sensitive visual interplay and punning characterize much of his work.

Herms has always exhibited freely, unlike Berman, and at times opened up his isolated studio home to hold sales of his work, which he called "Tap City Circuses."

Although some pieces contain stamped, textual elements, Herms' work is primarily composed of carefully selected and combined found objects. *Tail Light* (1973) incorporates the remains of a shattered automobile rear light cover and a fragment of yellowing, frayed paper (whatever print or image it might once have carried, too worn to be legible) mounted on the cracked and peeling surface of a slab of beautifully decaying wood. Meaning is evoked through subtle suggestion which involves the viewer's own experience and expectations.

The Blankfort gift joins another assemblage and three other works by George Herms in the Museum's collection.

70. *Tail Light,* 1973
Mixed media
13^{13}/$_{16}$ x 11^{3}/$_{8}$ in. (35.1 x 28.9 cm.)

DAVID HOCKNEY

English, b. 1937

*I started drawing then, [when I returned to
Los Angeles in 1966] drawing more and
more, from life. The one thing that had hap-
pened in Los Angeles...was that I had begun
to paint real things I had seen...as I'd never
...done in London...* ★

DAVID HOCKNEY

English artist David Hockney has
won international acclaim for his paint-
ings, drawings, and prints. He studied at
the Bradford College of Art, Bradford,
England, and at the Royal College of
Art, London, in the late fifties and early
sixties. He has taught at the University of
California at Los Angeles and at Berkeley.

His unique vision of Los Angeles
and his role among the young artists who
came to maturity in this city in the sixties
was underscored by the Museum's 1981
bicentennial exhibition, *Art in Los
Angeles—Seventeen Artists in the Sixties.*

Peter on Bed Seated (1968), a
portrait of Hockney's friend Peter
Schlesinger, exemplifies the sensitive,
linear drawing style for which Hockney
is famous. The Museum owns eight
graphic works by this artist.

*Hockney, David, *David Hockney,* Harry N. Abrams,
Inc., New York, 1976, pp. 103–104.

71. *Peter on Bed Seated,* 1968
Ink
16¾ x 13¾ in. (42.5 x 34.9 cm.)†

JENSEN

73. *Des Bild der Sonne (Picture of the Sun)*, 1966
Oil and ink on paper
29 x 23 ⅛ in. (73.7 x 58.7 cm.)†

ALFRED JENSEN

American, b. Guatemala, 1903–1981

I read [*Goethe's*] Zür Farbenlehre *once a year until I understood it—twenty-five years later. It's incomplete, you know.*★

ALFRED JENSEN

A rich carpet of color, surrounded by the aura of oil-soaked paper, explained by arcane formulae written in a tremulous hand, Alfred Jensen's *Des Bild der Sonne (Picture of the Sun)* exemplifies his lifetime study of ancient and mystical number systems and systems of proportion, divination, astronomy, and philosophy.

Born in Guatemala of a Danish father and a German mother, Jensen was early exposed to Guatemala's Mayan heritage. He went to sea at fifteen where he learned celestial navigation. He later studied art with Hans Hofmann, Charles Despiau, and Charles Desfresne. He visited Picasso, Matisse, Miró, and Giacometti, and in 1951 moved to New York. With the encouragement of his friend Mark Rothko he began seriously to paint.

His interest in Goethe's color theory, the Mayan calendar, Pythagorean geometry, Babylonian, Egyptian, and Aztec temple plans, the movements of stars, and the behavior of electromagnetic particles produced an art that is perplexing and esoteric. Clearly he sought universal truths through systems and relationships. His art has been compared to tantric diagrams, and this comparison is valid beyond the obvious visual correspondence. Like a tantric diagram, a Jensen painting is abstract, not directly explainable, and both forms seek to represent the invisible. Jensen's palette, too, is like that of tantric diagrams in his use of black and predominantly primary colors.

Unlike a tantric diagram, however, which has no aesthetic purpose but is ritual in intent, Jensen intended to make art. *Des Bild der Sonne,* obscure though its meaning may be, is a beautiful painting, combining a rich expressionistic use of paint with a solid geometric design.

This painting will enhance the Museum's holdings of ten prints by Alfred Jensen.

★Herrera, Philip, "Alfred Jensen, 1903–1981,"*Art in America,* summer 1981, p. 19.

JOHNS

74. *Flashlight,* 1967–69
Etching and aquatint 33/40
25⅞ x 19¾ in. (65.7 x 50.2 cm.)†

JASPER JOHNS
American, b. 1930

Using the design of the American flag took care of a great deal for me because I didn't have to design it. So I went on to similar things like targets—things the mind already knows. That gave me room to work on other levels. *

JASPER JOHNS

Johns' familiar American icons, while easing viewer anxiety generated by the elusive subject matter of Abstract Expressionist painting, set up a new kind of frustration for the viewing public—the paradox of the useless utilitarian object. His imagery includes flags that cannot wave, targets that cannot be shot at, drawers that cannot be opened, blinds that cannot be raised, and flashlights that cannot be switched on, creating a quality of unfulfilled expectancy.

These banal-objects-become-images characterized Johns' art from his first historic one-person exhibition in 1958 at the Leo Castelli Gallery through the late sixties. Johns worked in a rich encaustic technique and, along with Rauschenberg, effected the transition from the energetic painterliness of Abstract Expressionism to the deadpan slickness of Pop art. The profound influence of his centered icon-like imagery upon the art of the sixties cannot be exaggerated—the oeuvre of Bengston attests to it.

A master printmaker and technical innovator, Johns expressed some of his best-known images in graphic media. *Flashlight* (1967–69) is characteristic; a mundane object, it is displayed on a base as though it were an archaeological treasure or the emblem of some distinguished endeavor doomed to wait forever, never to perform its only useful function.

With the inclusion of this print, the Museum will own five works by Johns.

*Hughes, Robert, "Pictures at an Inhibition: Jasper Johns' New York Retrospective," *Time,* October 31, 1977, p. 84.

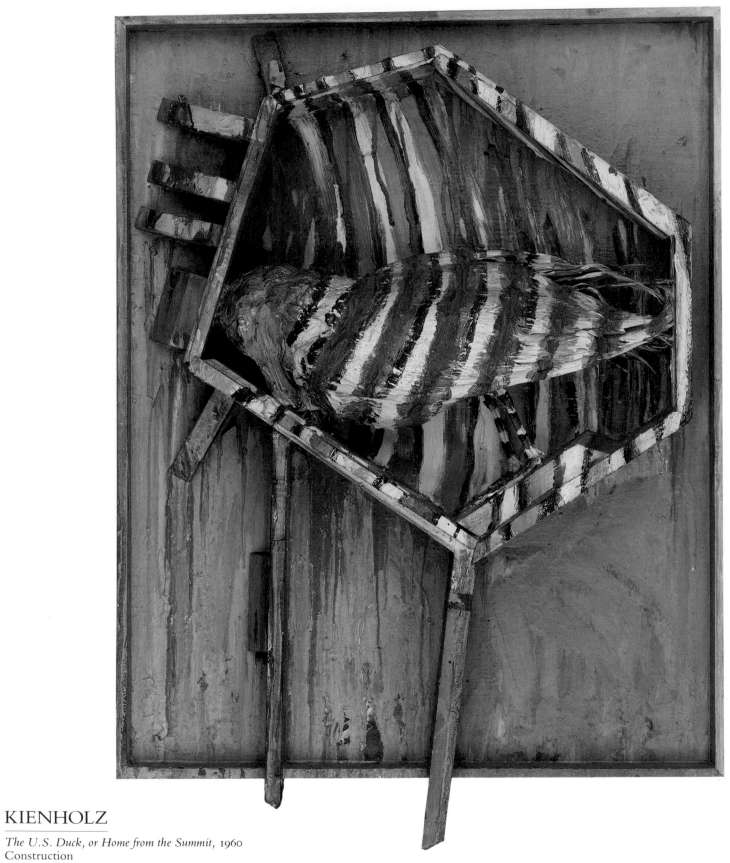

KIENHOLZ

80. *The U.S. Duck, or Home from the Summit*, 1960
Construction
26⁷/₁₆ x 21¹/₄ x 6 in. (67.2 x 54 x 15.2 cm.)

EDWARD KIENHOLZ

American, b. 1927

But all my work has to do with living and dying, our human fear of death.★
EDWARD KIENHOLZ

The transformation of trash into images of compelling social commentary has become the hallmark of this influential and socially conscious artist. Partly from simple economic necessity and partly for the pleasure of working with his hands and with substantial tools and materials, Kienholz took up the suggestion offered by the Dada *objet trouvé* and the junk sculpture of the fifties to create (with Wallace Berman) the California assemblage movement.

The Blankforts' friendship with and patronage of Kienholz dates from 1957, the year the Ferus Gallery opened and artist and collectors met. The untitled 1956 wood construction is characteristic of Kienholz' early work in its use of scraps of wood nailed and glued to a flat surface and overlaid with heavy paint that is applied with a kitchen broom or poured and pushed into thick ridges and masses.

The untitled 1957 watercolor bears a resemblance to the Black Paintings of Goya—a reference which is not surprising in view of the artists' similar interests and sensibilities. The application of heavy areas of varnish over parts of the surface adds to its expressive quality, and to the mystery of the shadowy images.

The U.S. Duck, or Home from the Summit (1960) refers to our inglorious return from the summit conference of that year. *The American Way, II* of the same year was acquired by contract from Kienholz (see Michael Blankfort's introduction). Lest these grim visual statements place the artist's warmth and humor in doubt, the following proviso (appended to the contract for *The American Way, II* in Kienholz' hand) is reproduced:

May 20, 1960

To Whom It May Concern:

In the event that Mike Blankfort at the end of 10 years (his chronological age of 62½) is to all intents and purposes by his say so, busted, I, Ed Kienholz or my heirs will not sue old Mike for $900.00 or any other sum including rental but will take back one art thing called "The American Way," and Mike can come to my house for dinner.

[s] Edward Kienholz
Edward Kienholz
in good health

Kienholz' imagery is usually complex and ironic. The etched metal work, *The Portable War Memorial 1968* (1970), relates to a tableau of the same name. The group of Marines is drawn from a renowned World War II photograph, but here they implant the American flag on a picnic table. His subject matter can also be direct and light-hearted. *For Rockwell Portable Saw 596* (1969) is a work of art created specifically in exchange for the object it names, needed to provision Kienholz' new home and studio in Hope, Idaho, where he moved in the early seventies after more than fifteen years in Los Angeles. *Merry Xmas* (1969) is similarly simple and straightforward—a greeting to friends.

Kienholz uses the discarded objects of our throwaway culture and infuses them with meaning, impelling the viewer to confront life "stripped of sham and hypocrisy" by his imaginative recycling.

The Blankfort gift includes six Kienholzes, which will significantly enlarge the Museum's present holdings of three works by this artist.

★Ayres, Anne Bartlett, "Berman and Kienholz: Progenitors of Los Angeles Assemblage," *Art in Los Angeles —Seventeen Artists in the Sixties,* exh. cat., Los Angeles County Museum of Art, 1981, p. 15.

78. *Untitled,* 1956 (inscribed "for Mike and Dorothy")
Wood construction
35⅞ x 26¼ in. (91.2 x 66.7 cm.)

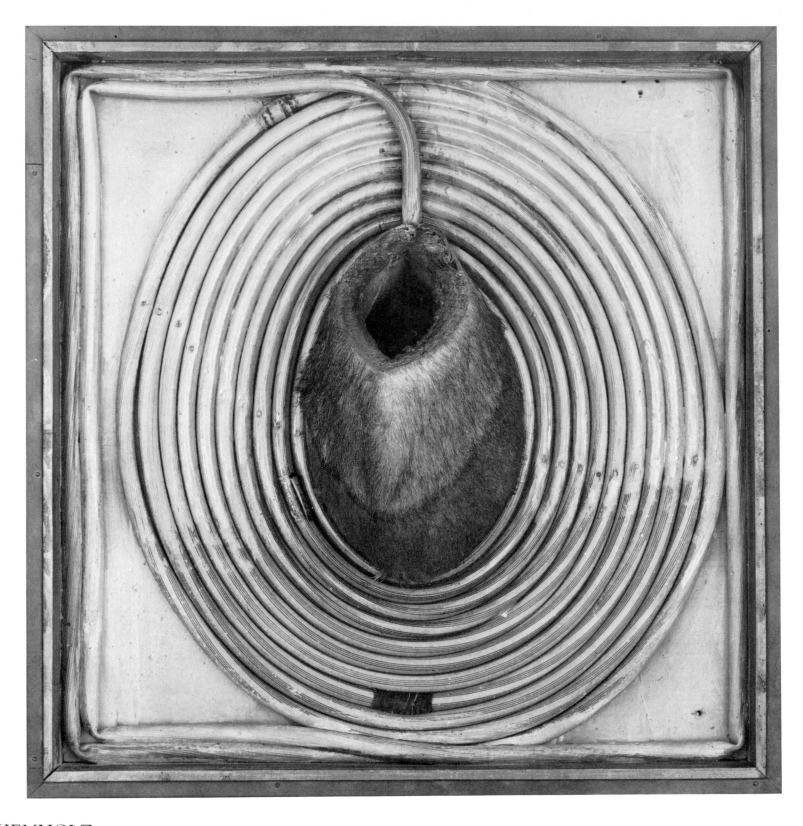

KIENHOLZ

81. *The American Way, II*, 1960
 Construction
 22¾ x 22¼ x 8 in. (57.8 x 56.5 x 20.3 cm.)

KIENHOLZ

79. *Untitled,* 1957
 Watercolor with crayon and varnish
 14^{15}/$_{16}$ x 19^{5}/$_{8}$ in. (38 x 49.8 cm.)†

• 83. *Merry Xmas,* 1969
 Watercolor and rubber stamping in galvanized
 metal frame 1/10
 8^{5}/$_{16}$ x 12^{3}/$_{16}$ in. (21.1 x 31 cm.)

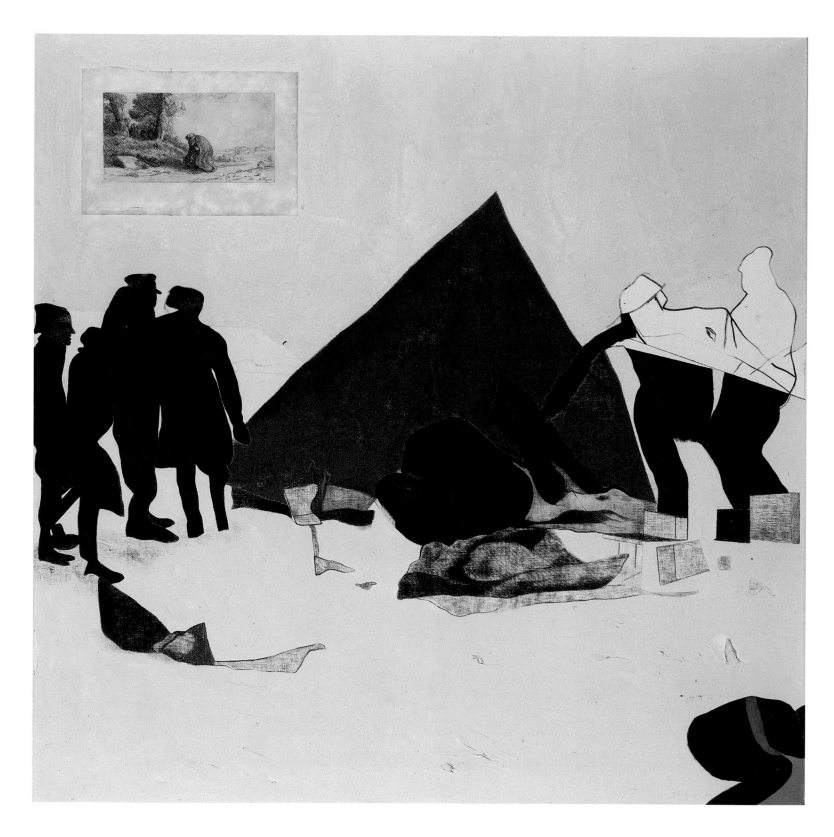

KITAJ

86. *Dismantling the Red Tent*, 1963–64
Oil and collage on canvas
48 x 48 in. (121.9 x 121.9 cm.)

R. B. KITAJ

American, b. 1932

If some of us wish to practice art for art's sake alone, so be it . . . but good pictures, great pictures, will be made to which many modest lives can respond. . . . it seems to be at least as advanced or radical to attempt a more social art, as not to.★

> *R. B. KITAJ*

Kitaj's eclecticism has been observed by scholars and acknowledged by the artist, who at times has appended lengthy bibliographies to his paintings. Fragments of quotations—visual and verbal—combine with the actual work of other artists used as collage elements; figures and images focus and fade, assembled in highly suggestive, unresolved ways; descriptive passages coincide with elusive silhouettes of photographic flatness. These elements fuse with Kitaj's mastery of line and elegant use of color into what is first and foremost beautiful painting.

Just as his style and technique defy specific description, so Kitaj's iconography defies precise explication. Yet *Dismantling the Red Tent* (1963–64), painted in the bleak winter after the assassination of President John Kennedy, evokes the drama and violence of that event with poetic force. Dark observers huddle against the cold swept by an unseen wind, while others do violence to someone inside the red tent. The cast shadow of one watcher intrudes from the lower right, creating a diagonal through the red tent to the Alphonse Legros etching at the upper left. The pyramidal form of the tent is echoed in the hunched, robed figure in the etching, and again in the blue triangular shape in the lower right corner.

In its complexity and obscurity, *Dismantling the Red Tent* exemplifies modern painting at its most sophisticated level; at the same time, its classical composition and monumentality of meaning are in the tradition of Poussin and the great history painters of the Western tradition.

Two London Painters (1979) and *Terese* (1978) attest both to Kitaj's skill as a draftsman and to his sensitivity to mood and nuance in the treatment of the human form.

The fifteen graphic works by Kitaj in this collection range in date from 1964 through about 1971, and represent a comprehensive survey of Kitaj's work in screenprinting for that period. Additionally, their study illustrates the broadness and depth of his intellect and imagination. Those of earlier date are now becoming rare.

The Museum's existing holdings of Kitaj's art include some eighty-six graphic works and the extant products of his involvement with the Museum's historic *Art and Technology* project from 1967 to 1971.

★Kitaj, R. B., "The Human Clay," *This Knot of Life*, exh. cat., L.A. Louver, Venice, California, 1979, p. 29.

• 92. *The Desire for Lunch is a Bourgeois Obsessional Neurosis or Grey Schizoids,* 1965 (inscribed "for Dorothy with love, Kitaj")
Screenprint, unnumbered (edition of 70, published by Marlborough Graphics)
29¾ x 20¼ in. (75.6 x 51.4 cm.)†

96. *Walter Benjamin,* 1966 (inscribed "for Mike")
Lithograph 4/10 (published by Marlborough Graphics)
13 x 9⅞ in. (33 x 25.1 cm.)†

KITAJ

97. *Kenneth Rexroth,* 1969 (inscribed "for Mike with love,
 Kitaj")
 Screenprint, unnumbered (edition of 70, published
 by Marlborough Graphics)
 20 x 29¾ in. (50.8 x 75.5 cm.)

100. *Immortal Portraits,* c. 1971
 Screenprint 16/70 (published by Marlborough Graphics)
 28⅛ x 44½ in. (71.3 x 113.1 cm.)†

KITAJ

101. *Terese,* 1978
 Pastel and charcoal
 22 x 15 in. (55.9 x 38.1 cm.)†

102. *Two London Painters: Frank Auerbach and Sandra Fisher,* 1979
 Pastel and charcoal
 22⅛ x 30⅞ in. (56.2 x 78.4 cm.)†

KLEIN

103. *Anthropometrie (ANT 159)*, 1962
 Oil on paper
 25 x 15¼ in. (63.5 x 38.7 cm.)

YVES KLEIN

French, 1928–1962

For me, color is sensitivity 'materialised' (sic) it is indeed, the abstract spacematter. ★

YVES KLEIN

Yves Klein, lying on a beach in southern France with his friends Arman (Arman Fernandez) and Claude Pascal, claimed the sky as his province when they divided the visible world between the three of them. He signed his name on the blue vault overhead and commenced his monochrome adventure.

Klein first began his monochrome paintings utilizing such colors as red or orange, but by 1957 he was executing all of them in a pure resonant ultramarine which came to be known as IKB (International Klein Blue). Chemical and optical analyses conducted at the Museum's Conservation Center laboratories confirmed that Klein used synthetic ultramarine, a manufactured pigment which is less expensive than natural ultramarine (lapis lazuli). Klein wanted to avoid using an oil medium which would have altered the appearance of the pure pigment; instead, he ground and mixed the ultramarine into an adhesive in his own mortar.

Klein's 1957 *Exhibition of the Void* —an empty gallery painted white— attracted thousands of spectators. The gallery was filled with "the surfaces and volumes of invisible pictorial sensitivity." In 1959 he began to exchange these *Zones of Immaterial Pictorial Sensitivity,* by contract, for gold, half of which was cast into a body of water while the receipt for the transaction was burned.

The *Anthropometrie* series began in 1958. Nude models, literally "body brushes," covered themselves with IKB and pressed, rolled, or dragged their bodies on the paper while Klein, wearing white tie and tails, directed the proceedings to the accompaniment of his "Symphonie Monoton"—ten minutes of C major followed by ten minutes of silence.

Other series followed. The *Cosmogonies* were a collaboration of the artist with wind or falling rain. *Fire Paintings* consisted of flame-seared surfaces, sometimes forming the silhouette-image of an *Anthropometrie.* Klein also conceived projects for fire sculpture—fountains of fire and water shaped by wind—and became a work of art himself, photographed falling through space.

In his last series, inspired by the birth of space travel, Klein employed filmy gold leaf (along with red, blue, and gold—the colors of flame) to create other-worldly images, planetary landscapes which he called *Monogold.*

Klein died of a heart attack at the age of thirty-four. A martial artist and mystic, this exceptionally imaginative artist embodied many of the radical directions of postwar European art, and foretold much of what was to happen in America in the sixties and seventies.

The Blankfort Collection includes *IKB Monochrome (IKB 218), Anthropometrie (ANT 159),* and *Immaterial Pictorial Sensitivity Zone No. 01, Series 4,* all of 1962. *Anthropometrie* will be the first work by Klein to enter the Museum's collection. The *Immaterial* is necessarily included in the form of documentary photographs.

★Klein, Yves, "The Monochrome Adventure," ed. Marcelin Pleynet, *Yves Klein,* exh. cat., The Jewish Museum, New York, 1967, p. 30.

• 104. *IKB Monochrome (IKB 218),* 1962
Oil on cloth on board
25¾ x 19⅝ in. (65.4 x 49.8 cm.)

KLINE

• 106. *Shaft*, 1955
Oil on canvas
24 x 29¹/₁₆ in. (61 x 73.8 cm.)

FRANZ KLINE

American, 1910–1962

. . . you paint the way you have to in order to give, that's life itself, and someone will look and say it is the product of knowing, but it has nothing to do with knowing, it has to do with giving.★

FRANZ KLINE

Franz Kline firmly belongs to the heroic period of Abstract Expressionism. He found his mature style around 1950 and is remembered for his irony, humor, generosity, and openness by his many friends from within the community of artists who formed his world.

Although every Kline painting appears to be the spontaneous record of an impulse—a moment—few were completed in a single sitting. Rather, most are the result of careful study, delicate exploration, and adjustment of balance. The impact of a Kline painting is generated from within, from the dynamism, intensity, and monumentality inherent in the image and field, rather than from its absolute dimensions. Many are, indeed, very large, but relatively smaller works, such as *Shaft* of 1955, have the immediacy and power of others many times their size.

Each of the major Abstract Expressionists went through a black-and-white period at some time, but only Kline made that spare palette so much his own. Perhaps what is so satisfying about a Kline painting is the energy and boldness of these dynamically balanced compositions realized in the most austere color scheme.

★Goldwater, Robert, *Franz Kline,* exh. cat., Marlborough Gerson Gallery, Inc., New York, 1967, p. 5.

RICO **LEBRUN**

American, 1900–1964

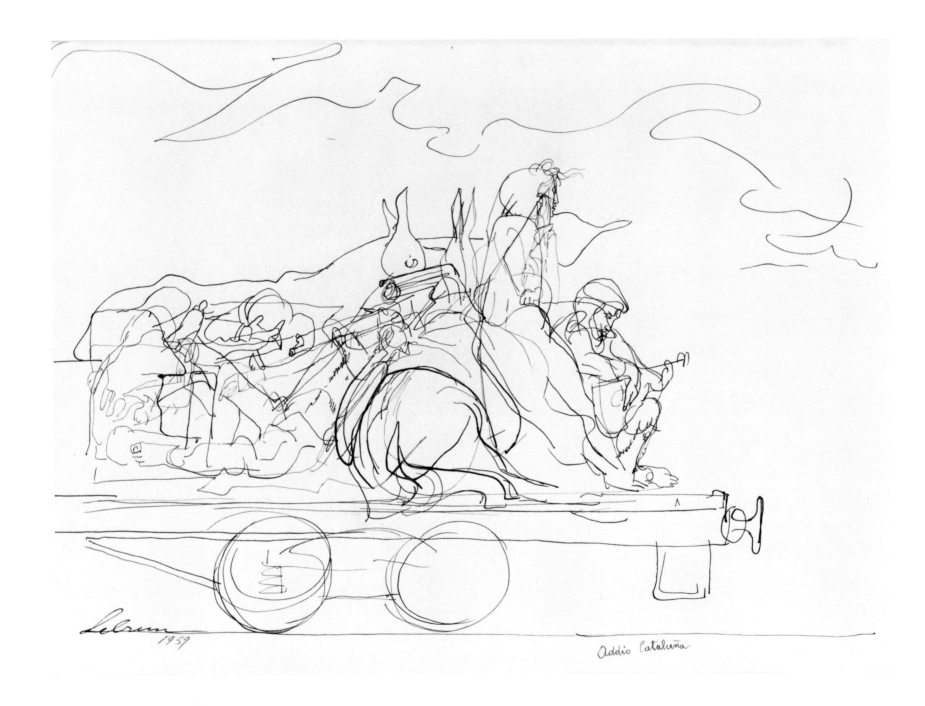

108. *Addio Cataluña,* 1939
Ink
11¹¹/₁₆ x 15³/₄ in. (29.7 x 40 cm.)†

LOREN MADSEN

American, b. 1943

111. *Corner piece—bricks & wire—c. 6'l x 6'w x 3½'h,* 1974
Ink and pencil
18⅛ x 23¼ in. (46 x 59 cm.)†

MARIN

•114. *New Mexico*, 1930
Watercolor
13¼ x 16½ in. (33.6 x 41.9 cm.)†

JOHN MARIN

American, 1870–1953

Seems to me the true artist must perforce go from time to time to the elemental big forms—Sky, Sea, Mountain, Plain—and those things pertaining thereto, to sort of re-true himself up, to recharge the battery. For these big forms have everything.★

JOHN MARIN

McKinley Helm wrote in 1929 that Marin "...felt the world closing in on him. He was 'tired of living in herds,' of swimming in a 'common pool.'" At the suggestion of his long-time friend Georgia O'Keeffe, Marin spent the summers of 1929 and 1930 in Taos, New Mexico, as the guest of Mable Dodge Luhan. The sparse New Mexico landscape afforded the escape and new inspiration he needed, and the brilliant watercolors of his summers in the West attest both to his profound reverence for nature and the sureness and certainty of his purpose.

New Mexico of 1930 represents the bald saddle of Lobo Peak in the Sangre de Cristo Range, and was probably painted from a site on Rio Hondo west of Valdez in October, after frost had reddened the scrub oak. The angular forms of the clouds echo the exaggerated sharpness of the peaks. The ambidextrous artist worked rapidly, sketching the contours of his composition and laying in broad areas of transparent color with one hand, adding details with the other. The paint dried rapidly in the desert air, but Marin sometimes scratched linear forms into the wet surface with a fingernail.

His architectural training and awareness of Cézanne and Cubism are evident in his work. Though always a realist painter, Marin recorded his perceived world in a kind of visual shorthand, eliminating the atmospheric interference which turns distant objects blue and hazy, thus creating a kaleidoscopic, fragmented flatness that is truly modern.

Sailboat is from a signed edition of about thirty prints made in 1932. In 1936 the plate was steel faced and a large unsigned edition was pulled.

★*Letters of John Marin,* ed. Herbert J. Seligman, privately printed for An American Place, New York, 1931, unpaginated.

• 115. *Sailboat,* 1932
Etching (signed outside the plate)
6⅝ x 9³⁄₁₆ in. (16.8 x 23.3 cm.)†

ARNOLD MESCHES

American, b. 1923

People are frequently heard to remark, when seeing a Mesches portrait, that the sitter looks familiar—a relative or friend, or someone seen often but not personally known. Since, however, the portraits are actually startling likenesses, this quality derives not from their typicality, but from their subtle evocation of the quality of memory. The portraits are not like snapshots, but are like the "snapshots" stored in the mind.

Although Mesches attended Art Center School (now Art Center College of Design), the Jepson Institute for Art, and Chouinard Art Institute, he is largely self-taught as an artist. *Jill's Mother #1* (1976) is in the descriptive, realist style for which Mesches is best known. He has also developed a unique hatch-mark technique of both drawing and painting, creating lifelike portraits from a network of fine lines.

The Museum owns one oil by Mesches in addition to the Blankfort gifts.

117. *Jill's Mother #1,* 1976
Acrylic on canvas
11 x 11 in. (28 x 28 cm.)

EDWARD MOSES

American, b. 1926

Edward Moses is a prolific producer of fine drawings which stand alone as finished works of art, though many are at the same time studies for paintings. In the late fifties, after a stint as a technical draftsman, and after producing coastal architectural landscapes in a schematized style, Moses began consciously to explore the language of Abstract Expressionism. He left his native Southern California to spend the years 1958 to 1960 in New York.

Page out of a Book of 1959 was produced during that time. Patches of red, yellow, and blue, combined with an energetic graphite calligraphy, are frosted over with white and glazed with varnish, intensifying the depth of color in some areas. The picture is evocative of the New York cityscapes of de Kooning, who was a powerful influence on many of the young West Coast artists in the late fifties. The title is suggested by the resemblance of the image to the centered, typeset area of a printed page.

The Museum owns one painting and several prints by Moses.

126. *Page out of a Book,* 1959
Pencil and crayon
17 x 14 in. (43.2 x 35.6 cm.)†

MOTHERWELL

127. *Spanish Elegy XV*, 1953
Oil on canvasboard
12 x 16 in. (30.5 x 40.6 cm.)

ROBERT MOTHERWELL

American, b. 1915

*All my life I've been working on the work
...Each picture is only an approximation of
what you want.... you can never make the
absolute statement, but the desire to do so as
an approximation keeps you going.*★
ROBERT MOTHERWELL

Robert Motherwell would have earned a place in twentieth-century art history for his editorship of the valuable Viking Press series *The Documents of 20th-Century Art* alone, but he was, in addition, one of the originators of the Abstract Expressionist movement in New York after World War II. Born in Washington state and raised in California, Motherwell was educated at Stanford, Harvard, and Columbia universities. He also studied for a time with medievalist and modernist art historian Meyer Schapiro.

The greatest theme of his painting has been the *Elegy to the Spanish Republic,* generated out of the artist's feelings for the desperate struggle of the Spanish against Franco and fascism. His interest in Spain expanded to include Spanish poetry and literature into his subject matter. The black-and-white palette, so often employed by Spanish artists, is used by Motherwell to evoke the contrasts and drama that are characteristic not only of Spain and the Spanish people, but of life in general.

"Black is death, anxiety; white is life, éclat. Done in the flat, clear Mediterranean mode of sensuality, but 'Spanish' because they are austere. ...I have been honored that various Spanish painters... have exhibited a certain interest in them. ...But they are much more than 'Spain.'"

The Museum presently owns one print by Robert Motherwell.

★Glueck, Grace, "Motherwell, at 61, Puts 'Eternal Quality' into Art," *New York Times,* February 3, 1976.

MULTIPLE: D'ARCANGELO, DINE, LICHTENSTEIN, OLDENBURG, SEGAL, WARHOL, WESSELMANN

129. *Seven Objects in a Box*, 1966
Mixed media 8/75 (published by Tanglewood Press, New York)
a. Allan D'Arcangelo (American, b. 1930)
Side View Mirror, 1966
7¼ x 4¾ x 6¼ in. (18.4 x 12.1 x 15.9 cm.)

b. Jim Dine (American, b. 1935)
Rainbow Faucet, 1966
5½ x 2⅝ x 4¾ in. (14 x 6.7 x 12.1 cm.)

c. Roy Lichtenstein (American, b. 1923)
Sunrise, 1967 (illustrated)
8⁹/₁₆ x 11 in. (21.7 x 28 cm.)

d. Claes Oldenburg (American, b. Sweden, 1929)
Baked Potato, 1967
4¾ x 10⁷/₁₆ x 7³/₁₆ in. (12.1 x 26.5 x 18.3 cm.)

e. George Segal (American, b. 1924)
Chicken, 1966
17 x 17½ x 3½ in. (43.2 x 44.4 x 8.9 cm.)

f. Andy Warhol (American, b. 1928)
Kiss, 1967
12⅛ x 8 in. (30.8 x 20.3 cm.)

g. Tom Wesselmann (American, b. 1931)
Little Nude, 1966
7¾ x 7⅝ x 1 in. (19.7 x 19.3 x 2.5 cm.)

LOUISE NEVELSON

American, b. Russia, 1900

132. *Verso,* 1959
Wood, nails, and paint
32¹/₁₆ x 28¹/₈ x 3¹/₈ in. (81.4 x 71.4 x 7.9 cm.)
M.73.80

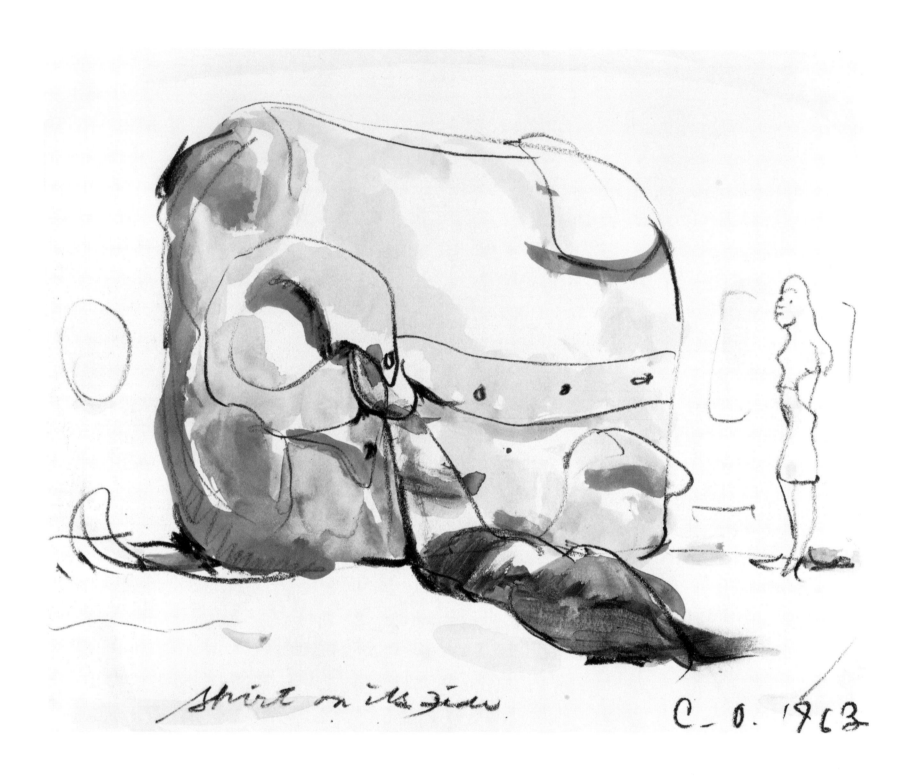

OLDENBURG

133. *Visualization of a Giant Soft Sculpture in the Form
of a Shirt with Tie (Shirt on Its Side),* 1963
Watercolor and crayon
14 x 16½ in. (35.5 x 41.9 cm.)†

CLAES OLDENBURG

American, b. Sweden, 1929

I have always been fascinated by the values attached to size. Aside from the technical accomplishment involved, why is a four-hundred-foot-high clothespin more valuable than one I can hold in my hand? Also, considerations of size are a way to ask into the reality of vision . . . The first 'monument' drawings were like stereoscopic combines of two viewpoints—a small thing viewed close seeming 'colossal' because of its superimposition on a large thing viewed from afar.★
CLAES OLDENBURG

Claes Oldenburg is probably the best-known Pop sculptor of this country. He achieved this distinction through his giant early images of food and clothing sculpted of stuffed canvas and painted in a loose, Abstract Expressionist style (later crafted in slick plastics), and through his proposals for monuments and buildings. Some of these latter concepts have actually been executed in full-scale, such as the giant three-way plug at Oberlin College in Ohio, while others have been the subject of serious feasibility studies by architecture students.

Many of Oldenburg's proposals and studies for sculpture or monuments, which may or may not have been realized in three dimensions, exist as lovely watercolor drawings—one of their most pleasing manifestations. *Visualization of a Giant Soft Sculpture in the Form of a Shirt with Tie (Shirt on Its Side)* of 1963, and *Proposed Colossal Monument for Ellis Island: Frankfurter with Tomato and Toothpick* of 1965 both exhibit Oldenburg's virtuoso mastery of the drawn line. With the casual, almost off-hand application of a few strokes of color, these pieces delight and convince the eye. Both of these widely exhibited drawings display that gentle eroticism which pervades so much of Oldenburg's art; the tie and frankfurter in the most oblique and nonaggressive way evoke phallic forms. Additionally, the *Frankfurter* is an ironic social comment:

the immigrants who came to Ellis Island expected Thanksgiving dinner, but they received—at best—hot dogs.

The Blankfort gift of four Oldenburgs will significantly enlarge the Museum's holdings of four works by this artist.

★Legg, Alicia, *Claes Oldenburg,* exh. cat., Arts Council of Great Britain, 1970, p. 8.

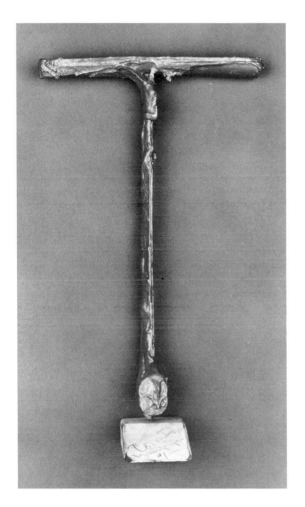

136. *Toronto Drainpipe #1, 1967* (three-dimensional study for *Toronto Drainpipe*)
Plaster, wood, and paint
21¾ x 12½ x 7 in. (55.7 x 31.8 x 17.8 cm.)

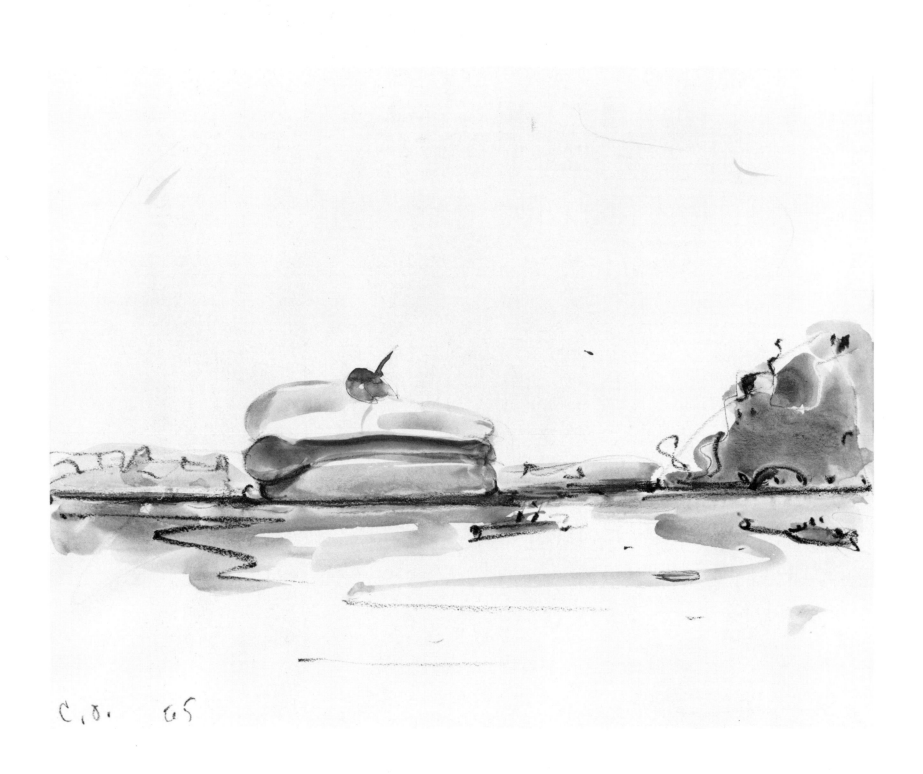

C.O. 65

OLDENBURG

• 134. *Proposed Colossal Monument for Ellis Island: Frankfurter with Tomato and Toothpick*, 1965
Watercolor and pencil
18⅜ x 23⅜ in. (46.6 x 59.3 cm.)†

RICHARD POUSETTE-DART

American, b. 1916

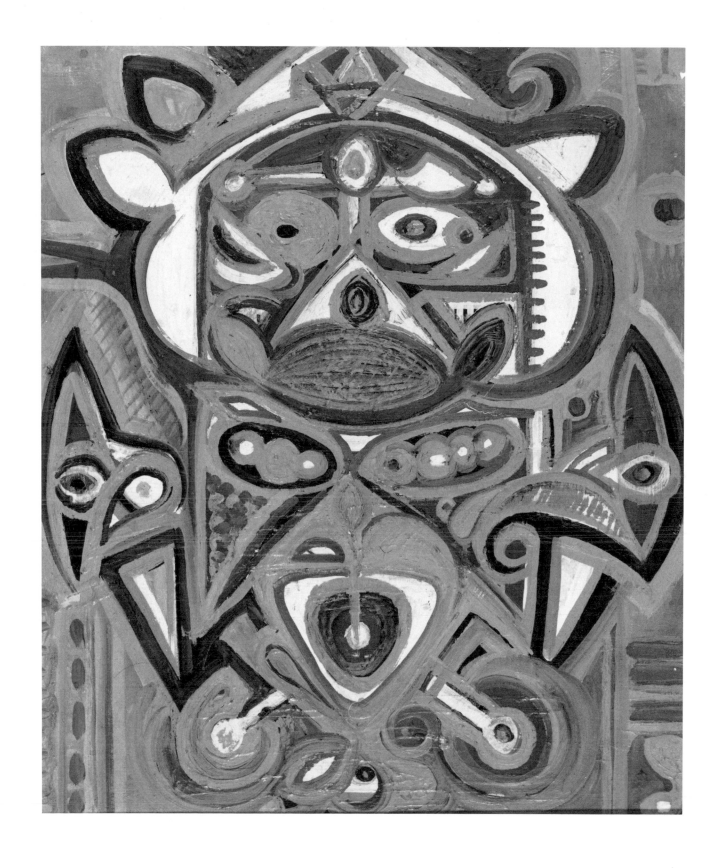

139. *Chrome Image,* 1941
Oil on canvas
24 x 20 in. (61 x 50.8 cm.)

RAUSCHENBERG

144. *Cardbird I*, 1971
Lithograph and collage on cardboard 37/75
44¾ x 30 in. (113.7 x 76.2 cm.)

ROBERT RAUSCHENBERG

American, b. 1925

For those of us who had the opportunity to witness Rauschenberg apply his incisive vision to the graphic ritual, our lives and perceptions were profoundly changed. However carefully guarded our prior aesthetic may have been, it was irrevocably altered by the form as process in his work . . . an expanded understanding . . . of the nature of reality . . . and the touch of man. . . .★

DONALD J. SAFF

Robert Rauschenberg had a major role as a transitional figure between Abstract Expressionism and the Pop art movement that emerged in the sixties. His "combines" are works that unite found objects with heavy masses of expressively applied paint in ambiguous compositions that are neither painting nor sculpture, but rather something in between. Similarly, the subject matter of the combines contains the abstract elements of the movement from which he sprang, as well as the banal images that were to be exploited by Pop artists. His expressive use of found objects influenced the development of the California assemblage movement.

As a graphic artist, Rauschenberg ranks with the best of the Western tradition. To that tradition he has contributed significantly, not only through his exploration of media and techniques which advanced the printmaking craft, but also through his highly imaginative iconography.

Cardbird I and *II* of 1971 are verbal and visual puns: cardboard becomes cardbird in torn pieces of cardboard boxes combined with *trompe l'oeil* silkscreened fragments, actual and illusionistic tape, and real and fake shipping labels. The play between illusion and reality in these pieces combines with the allusive title in a sophisticated interplay.

There are seven other works by Robert Rauschenberg in the Museum's collection.

★Saff, Donald J., *Rauschenberg at Graphicstudio,* exh. cat., Library Gallery, University of South Florida, Tampa, 1974, (acknowledgment).

145. *Cardbird II,* 1971
Lithograph and collage on cardboard 37/75
54½ x 33⅝ in. (138.4 x 85.4 cm.)

MAN RAY

American, 1890–1976

146. *Cadeau (Gift),* 1963 (replica of 1921 original,
 signed by the artist)
 Flat iron with nails 6/10
 5 1/2 x 3 7/16 x 3 1/2 in. (14 x 8.7 x 8.9 cm.)

LARRY <u>RIVERS</u>

American, b. 1923

• 148. *Yves Klien* [Klein], 1961
Pencil
13 x 15½ in. (33 x 39.3 cm.)†

SAUL

154. *Untitled*, 1962
Oil on canvas
51 ⅛ x 59 in. (129.8 x 149.9 cm.)

PETER SAUL

American, b. 1934

People look somehow more real when they resemble cartoons.★

PETER SAUL

Provoked by the chaos and commercialism of contemporary life, Peter Saul's imagery holds up a mirror to perversion, corruption, and violence, and reflects them back in the colors of Disneyland and advertising.

The deceptively cheerful aura of his untitled 1962 oil is dispelled when the viewer perceives the policeman, whose insignia is a dollar sign, riveting a refrigerator full of beer with his eyeless gaze. His arm metamorphoses into an undulating pipe down which a toy boat sails. Enormous hands proffer a huge citrus half from a bathtub in which figures grapple. The bathtub stabs itself. A toilet seat spews chartreuse, flanked by a curtained window and a disembodied leg escaping from a valise.

His brilliant color as well as the ability of his images to metamorphose into erotic forms recall Gorky and Miró. The liveliness of his inanimate objects is suggestive of the anthropomorphic machinery of Dada. Distortions of scale and space are reminiscent of Cubism and, at the same time, of the techniques of advertising, through Saul's use of exaggeration, repetition, and sexual imagery.

Saul's concern is genuine: "I will show people that what they most want to look at is not the kind of thing that they will enjoy seeing." But he characterizes himself as "softhearted," wanting to show ". . . that human things are really okay."

The colorful, 1960 untitled pastel, in Saul's characteristic style, has been on loan to the Museum from the Blankforts since 1963.

Saul's work of the seventies and that of the eighties continues to deal with the same themes in the same intense color, but with greater expressive distortion.

These two works by Peter Saul are the first to enter the Museum's collection.

★"Discredited Merchandise," *Newsweek,* November 9, 1964, pp. 94–96.

153. *Untitled,* 1960
Crayon and pastel
20¾ x 35 in. (52.7 x 88.9 cm.)
L.2364.63-25

ANTONIO SAURA

Spanish, b. 1930

155. *Retrato de Felipe II*, 1959
Oil on canvas
51 x 38 in. (129.5 x 96.5 cm.)
L.2364.61-3

EGON SCHIELE

Austrian, 1890–1918

159. *Untitled,* 1918
 Black crayon
 18¼ x 11⅝ in. (46.3 x 29.5 cm.)†

The human image—in portrait, figure study, and group—has been a major preoccupation of the art of Northern Europe from medieval times. Even in the Renaissance, when classicizing values tended outwardly to soften the artist's penetrating vision, the inner psychological state was usually the true subject of a portrait.

This intensive contemplation—of the self and one's fellows—reached one of its peaks in the brief career of Viennese artist Egon Schiele. The 1918 untitled drawing of two women is the first Schiele drawing to enter the Museum's collection. The artist chose an unusual, high viewpoint and placed the two figures off-center and overlapping in a composition of studied elegance. Despite the deliberate quality of this arrangement, the drawing remains spontaneous and gestural. The *doppelgänger,* or double image, was a major theme in Schiele's art.

In *Self-Portrait* (1912) the artist regards himself stripped of the comfort that could be derived from garment or context. His own full-length mirrored image (in French, the *psyche*) obsessed him, and here he regards himself sidelong, but mercilessly. The lithograph was published in Munich as part of a portfolio which included work by various artists including Paul Klee and Max Oppenheimer.

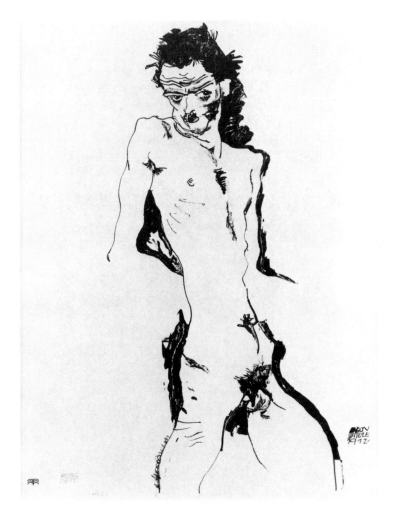

SCHIELE

158. *Männlicher Akt. Selbstbildnis I. (Male Nude. Self-Portrait I.),* 1912
Lithograph on vellum no. 21 (signed and dated outside the stone)
17⅝ x 15¾ in. (44.7 x 40 cm.)†

TERRY SCHOONHOVEN
VICTOR HENDERSON

[Isle of California] *is about the great earthquake myth.*★

 TERRY SCHOONHOVEN

 The Blankfort study is the last extant correction drawing for the L.A. Fine Arts Squad's large mural on Butler Avenue in Santa Monica, titled *Isle of California* (1971). The mural depicts the broken remains of one of Los Angeles' ubiquitous architectural features—the freeway overpass—in the wasteland left after the "great quake." The drawing is an actual photograph of the mural in progress, showing the upper portions complete. In the lower section, the cartoon is still visible. The corrections have been drawn with pencil and overlaid with a grid for transfer to the mural. Unlike other murals by the Squad, such as *Beverly Hills Siddhartha, Venice in the Snow,* and *Ocean Front Painting,* which depict their surroundings in *trompe l'oeil, Isle of California* is a fantasy about California's most dreaded catastrophe. The choice of subject relates to the concerns of its patron, who had interests in offshore oil drilling.

 The Squad was formed in 1969 by a group of young realist painters in Venice, California, but by the mid-seventies, the Squad was reduced to Schoonhoven and Victor Henderson. Since 1975 Schoonhoven has continued to paint large, illusionistic murals alone. His twenty-foot-long painting *Downtown Los Angeles Underwater* of 1979 was acquired by the Museum in 1981. His mural, *Generator (Study in Copper and Grey),* painted in 1981 on the east facade of the Ahmanson Gallery was one of the works featured in the bicentennial exhibition, *Art in Los Angeles—The Museum as Site: Sixteen Projects,* and has been given to the Museum by the artist. of the artist.

The Blankforts also hold the deed to one square foot of *Ocean Front Painting* in Venice by the Squad.

★Statement to Anne Edgerton, September 1981.

Terry Schoonhoven and Victor Henderson
American, b. 1945; American, b. 1939
160. *Isle of California,* 1971
Pencil and acrylic on photograph
29½ x 39½ in. (74.9 x 100.3 cm.)†

SMITH

161. *Untitled*, 1957
Oil on canvas
68 x 46 in. (172.7 x 116.9 cm.)
M.64.8

HASSEL SMITH

American, b. 1915

*It was my feeling, when I first elected the
non-objective or non-figurative way, that it
was better to create something and risk being
chained to the rock than to go on in that end-
less rat race of celebration and blasphemy.*★

HASSEL SMITH

A former student of the Califor-
nia School of Fine Arts in San Francisco,
Smith was teaching at that institution
when Richard Diebenkorn was a student
there in the late forties. With Diebenkorn,
Clyfford Still, Elmer Bischoff, and
others, Smith was a primary figure of the
insurgent Bay Area school of painting
following World War II. His work,
exhibited at the Ferus Gallery in the late
fifties, influenced young artists then
coming to maturity in Los Angeles.

Finding figurative painting bank-
rupt because of its imposition upon the
artist of values and strictures not his own,
Hassel Smith committed himself com-
pletely to abstract painting. The untitled
1957 oil, a 1964 gift of the Blankforts
to the Museum, is one of Smith's finest
and most satisfying works. The lively red
and orange of the field is energized with a
wiry, black calligraphy.

★Mac Agy, Douglas, *Hassel Smith,* exh. cat., André
Emmerich Gallery, New York, 1961, unpaginated.

162. *Goofy Dufy,* 1958
Oil on canvas
68¹³/₁₆ x 38¹³/₁₆ in. (174.8 x 98.6 cm.)

SAUL STEINBERG

American, b. Rumania, 1914

Saul Steinberg has characterized himself as "a writer who draws" and his drawings have been reproduced by the hundreds in *New Yorker* magazine and on its cover. A Rumanian raised in Bucharest, Steinberg earned his doctorate in architecture in Milan in 1940. Two years later he came to America. His work has been exhibited widely and has enjoyed universal acclaim.

His most recent series, *Tables,* are actual tabletops that display his drawings and watercolors, as well as whittled, painted reproductions of his tools. Rubber stamp imagery and typographic elements carry over to the *Tables* series from his sixties work. *Rimbo Table* of 1973, includes a pencil stub, ruler, drawing pen, an official-looking stamp, a bleak, little landscape—whose sky nevertheless gets the stamp of approval —and a zinc plate with an etched mouse-creature. No particular interrelationship seems to be suggested other than the obvious—the artist's tools and his product.

• 163 . *Rimbo Table,* 1973
Polychromed wood, oil on board, and etched metal
21¼ x 16⅜ in. (54 x 41.6 cm.)†

ESTEBAN VICENTE

American, b. Spain, 1903

168. *Orange-Black,* 1958
Collage
25 ¾ x 16 in. (65.4 x 40.6 cm.)†

The problem of painting in all times has been to achieve clarity, but clarity is a subjective force. It is realized when the maximum of meaning is obtained with the minimum of elements.★

ESTEBAN VICENTE

Esteban Vicente was born in Segovia, Spain, and studied at the School of Fine Arts of San Fernando in Madrid before moving to Paris. He began as a student of sculpture, and later he switched to painting. In 1936 he came to New York, where his interest in European Modernism was enlivened by the raw energy of the work of his friends de Kooning and Kline.

Vicente began to work with collage in the early fifties while teaching at the University of California, Berkeley. Finding himself without paint or brushes, he tore up colored paper in order to work. The collages, while considered studies for paintings by the artist, stand alone as finished works of art. Vicente combines torn fragments of hand-painted papers with an elegant and economic use of charcoal in works that are reminiscent of Cubism.

Vicente has taught at some of the most distinguished American art schools, including Yale University; New York University; Queen's College, New York; Black Mountain College, North Carolina; and Princeton University. It was during a summer teaching appointment at the University of California, Los Angeles, in 1962 that Vicente made *Comstock* while living at the Blankfort home.

Two of these three works will join Vicente's 1957 *Collage with Grey and Brown* in the Museum's collection.

★Seitz, William C., *Esteban Vicente,* exh. cat., The Art Museum and the Creative Arts Program, Princeton University, 1966, unpaginated.

VICENTE

169. *Untitled,* 1961 (inscribed "To Dorothy & Michael")
Charcoal
16¾ x 22⅜ in. (42.5 x 56.8 cm.)†

EMERSON WOELFFER

American, b. 1914

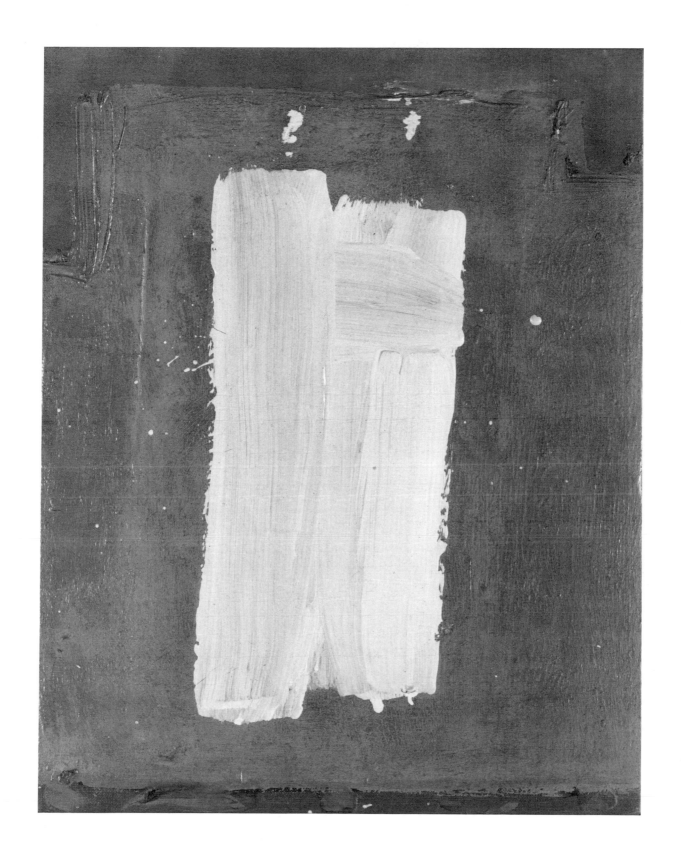

177. *Orange Night,* 1961
 Oil on canvas
 14⅛ x 11 in. (35.8 x 27.9 cm.)

Underneath the sensuousness is something more ominous and disparate, a kind of ineffable question asked and answered with ambiguity and subtlety.... The longer you look at [Woelffer's] work, the less you are aware of its immediate appeal and the more of its humanity.★

ROBERT MOTHERWELL

Emerson Woelffer was artist in residence at Colorado Springs Fine Arts Center when he and Robert Motherwell met. Born in Chicago and educated at the Chicago Art Institute, he later taught at the Chicago Institute of Design at the invitation of Moholy-Nagy, and at Black Mountain College, North Carolina. When his tenure in Colorado ended in 1956, Woelffer came to Southern California to stay. He taught at Chouinard Art Institute from 1959 to 1969 and continued at that institution—now the California Institute of the Arts at Valencia —until 1973.

The qualities to which Motherwell refers are exhibited in Woelffer's work by his finely controlled balance of color, mass, and line. *Wrapping Paper* (1958) and *Orange Night* (1961) are studies in economy of color and shape.

Summer Poet #7 (1978) creates an entirely different effect with its velvet-textured painted papers and exquisitely controlled depth of field. This collage is part of a series in homage to the Surrealist poets Alfred Jarry, Tristan Tzara, and André Breton. The elusive sugges-tion of a profile combines with the play between torn and cut edges and between silhouette and shadow to produce an image which is highly evocative of Surrealist juxtaposition and interplay.

The Blankfort gift of two collages and one oil painting will be the first Woelffers to enter the Museum's collection.

★Motherwell, Robert, *Emerson Woelffer: Paintings and Collages,* exh. cat., Gruenbaum Gallery, New York, 1978, p. 6.

WOELFFER

176. *Wrapping Paper,* 1958
Collage
17$^{11}/_{16}$ x 13$^{3}/_{4}$ in. (44.9 x 34.9 cm.)†

178. *Summer Poet #7,* 1978
Collage with painted paper
8 x 6 in. (20.2 x 15.2 cm.)†

CHECKLIST

Checklist of the Michael and Dorothy Blankfort Collection

JOSEF ALBERS
American, b. Germany, 1888–1976

1. *Homage to the Square: Yellow Echo,* 1956
Oil on canvas on board
30 x 30 in. (76.2 x 76.2 cm.)
Provenance: Ferus Gallery, Los Angeles.
Exhibition: *The Theater Collects American Art,* Whitney Museum of American Art, New York, 1961.

MARTHA ALF
American, b. 1930

2. *White and White,* 1973
Oil on canvas
28 x 28⅛ in. (71.1 x 71.4 cm.)
Provenance: Ellie Blankfort Gallery, Los Angeles.
Exhibition: *Black and White Are Colors,* Lang Art Gallery, Scripps College, Claremont, California, 1979.
Literature: Rubin, David S. and David W. Steadman, *Black and White Are Colors,* exh. cat., 1979, cat. no. 19, ill. p. 49.

3. *Woven Canvas #9,* 1973
Acrylic on canvas
23⅞ x 22¹/₁₆ in. (60.6 x 56 cm.)
Provenance: Ellie Blankfort Gallery, Los Angeles.

JOHN ALTOON
American, 1925–1969

4. *Untitled,* 1955
Oil on canvas
34¹/₁₆ x 44⅞ in. (86.5 x 114 cm.)
Provenance: Acquired from Edward Kienholz.

BENNY ANDREWS
American, b. 1930

5. *Rhoda,* 1970
Collage and oil on canvasboard
12 x 8¹⁵/₁₆ in. (35 x 22.7 cm.)
Provenance: Tirca Karlis Gallery, Provincetown, Massachusetts.
Exhibition: *Art of Black Americans, '73,* Santa Barbara Museum of Art, California, 1973.

AVIGDOR ARIKHA
Israeli, b. Rumania, 1929

6. *Self-Portrait with Open Mouth,* 1973
Aquatint 4/20
10¹³/₁₆ x 9⁷/₁₆ in. (27.5 x 24 cm.)†
Provenance: Acquired from the artist.

7. *Anne Leaning on a Table,* 1977
Oil on canvas
51³/₁₆ x 38³/₁₆ in. (130 x 97 cm.)
M.79.153

Provenance: Marlborough Fine Art Ltd., London. The Michael and Dorothy Blankfort Collection (gift to the Los Angeles County Museum of Art, 1979).
Exhibitions: *Avigdor Arikha,* Marlborough Fine Art Ltd., London, 1978. *Avigdor Arikha, Twenty-two Paintings,* Corcoran Gallery of Art, Washington, D.C., 1979. *Paris Art Fair, 1979. Israeli Artists: 1920–1980* - The Jewish Museum, New York, 1981.
Literature: *Avigdor Arikha,* Marlborough Fine Art Ltd., London, 1978, ill. p. 2, detail cover. Hughes, Robert, "Arikha's Elliptical Intensity," *Time,* July 30, 1979, p. 73. Livingston, Jane, *Avigdor Arikha: Twenty-two Paintings,* exh. cat., 1979, cat. no. 15.

ARMAN (ARMAN FERNANDEZ)
French, b. 1928

8. *Untitled,* n.d.
Screenprint 23/100
25⅝ x 19¹¹/₁₆ in. (65.1 x 50 cm.)†

MILTON AVERY
American, 1893–1965

• 9. *Seated Nude,* 1957
Oil on board
15⁷/₁₆ x 11⁵/₁₆ in. (39.2 x 28.7 cm.)†
Provenance: Esther Robles Gallery, Los Angeles.

BILLY AL BENGSTON
American, b. 1934

10. *Untitled,* 1957
Oil on canvas
33½ x 32⅛ in. (85.1 x 81.6 cm.)
Provenance: Ferus Gallery, Los Angeles.
Exhibitions: *Collector's Choice,* Los Angeles Institute of Contemporary Art, 1975. *50's Abstract,* Conejo Valley Art Museum, Thousand Oaks, California, 1980.
Literature: *50's Abstract,* exh. cat., 1980, ill. (unpaginated).

11. *Untitled* (Cannes), 1958
Collage with ink and watercolor
12⅜ x 9½ in. (31.4 x 24.1 cm.)
Provenance: Acquired from the artist.

12. *I Tatti,* 1961
Oil and lacquer on board
14 x 14 in. (35.5 x 35.5 cm.)
Provenance: Ferus Gallery, Los Angeles.
Exhibition: *de A à Z 1963,* Centre Culturel Américain, Paris, 1963.

13. *Untitled,* c. 1968
Lacquer on aluminum
24 x 22 in. (61 x 55.9 cm.)
Provenance: Acquired from the artist.

• 14. *Untitled* (Lahaina series), 1978
Watercolor
12 x 10⅝ in. (30.5 x 27 cm.)†
Provenance: James Corcoran Gallery, Los Angeles.

TONY BERLANT
American, b. 1941

15. *Rainbo,* 1963
Metal collage
9¾ x 10 in. (24.8 x 25.3 cm.)
Provenance: David Stuart Galleries, Los Angeles.

16. *Elegy for Chicken Little,* 1963
Construction with paint
23¹⁵/₁₆ x 21¹/₁₆ in. (60.9 x 53.5 cm.)
Provenance: David Stuart Galleries, Los Angeles.

WALLACE BERMAN
American, 1926–1976

17. *Untitled,* 1968
Verifax collage and paint
10¹³/₁₆ x 11¾ in. (27.5 x 29.8 cm.)†
Provenance: Acquired from the artist through the exhibition *Wallace Berman,* Los Angeles County Museum of Art, 1968.
Exhibitions: *Wallace Berman,* Los Angeles County Museum of Art, 1968. *Wallace Berman Retrospective,* Otis Art Institute, Los Angeles, 1978–80 (traveled to Fort Worth Art Museum, Texas; University Art Museum, University of California, Berkeley; Seattle Art Museum, Washington). *The Film and Modern Art,* Constitutional Rights Foundation, Los Angeles, 1979.

JOSEPH BEUYS
German, b. 1921

18. *Unveiling,* 1957
Ink and rubber stamping 25/40
5¾ x 8¼ in. (14.6 x 21 cm.)†
Provenance: Ronald Feldman Fine Arts, Inc., New York.

YEHOSHUA BRANDSTATTER
Israeli, b. Poland, 1891–1975

• 19. *Fields,* 1966
Oil on canvas
17¼ x 20¾ in. (43.8 x 52.7 cm.)†
Provenance: Acquired from the artist.

WILLIAM BRICE
American, b. 1921

20. *Interior II,* 1961
Lithograph (Tamarind impression no. 461)
35 x 26 in. (88.9 x 66.1 cm.)
M.62.44.46
Provenance: Tamarind Workshop. The Michael and Dorothy Blankfort Collection (given to the Los Angeles County Museum of Art, 1962). This print was selected to represent the suite of 431 Tamarind prints given by the Blankforts to the Museum.

BYRON BROWNE
American, 1907–1961

21. *Still Life with Branches,* 1940
Casein
7⁷/₁₆ x 9½ in. (18.9 x 24.1 cm.)†
Provenance: Ernest Raboff Gallery, Los Angeles.

CAROLE CAROOMPAS
American, b. 1946

22. *Twin Folds,* 1975
Mixed media
12¾ x 12⅜ in. (32.4 x 31.4 cm.)
Provenance: Ellie Blankfort Gallery, Los Angeles.

ANDREA CASCELLA
Italian, b. 1920

23. *Memorial for Auschwitz,* 1959
Bronze maquette (for projected unit in a series of 23 cement and iron boxcars)
4⅞ x 12 x 3¹³/₁₆ in. (12.4 x 30.5 x 9.2 cm.)
Provenance: Acquired from the artist.

• 24. *Untitled,* 1966
Marble (articulated)
6¹³/₁₆ x 2¾ x 2⅝ in. (17.3 x 7 x 6.7 cm.)
Provenance: Grosvenor Gallery, London.

WILLIAM COPLEY
American, b. 1919

25. *Untitled,* 1964
Ink
9 x 12 in. (22.8 x 30.5 cm.)†
Provenance: David Stuart Galleries, Los Angeles.

ROBERT CREMEAN
American, b. 1932

26. *Model and Towel #2,* 1958
Wood mortise
16⁹/₁₆ x 13⅜ x 8⅜ in. (42.1 x 34 x 21.3 cm.)
Provenance: Paul Kantor Gallery, Beverly Hills.

EDWARD CURTIS
American, 1868–1952

27. *The Old Warrior—Arapaho,* n.d.
Photograph
16¼ x 12⅛ in. (41.3 x 30.7 cm.)†

DANIEL CYTRON
American, b. 1945

28. *Tape Piece,* 1972 (inscribed "for Dossie")
Chart tape
18¾ x 13½ in. (47.6 x 34.3 cm.)†
Provenance: Greenson Gallery, Los Angeles.

HONORÉ DAUMIER
French, 1808–1879

29. *Bigre! . . . j'ai eu tort de me mettre toute l'Europe sur les bras! . . . (Good grief! . . . what a mistake that was on my part to put all of Europe on my shoulders! . . .),* 1855
Lithograph (from *Charivari,* 2–3 January 1855)
8⅞ x 11³/₁₆ in. (22.6 x 28.4 cm.)
Provenance: Gift of Dr. Armand Hammer.
Literature: Delteil, Löys and Nicolas Auguste Hazard, *Catalogue raisonné de l'oeuvre lithographié de Honoré Daumier,* Oise, France, 1904, vol. VII, no. 2542.

WILLEM DE KOONING
American, b. Holland, 1904

30. *Man,* c. 1947
Pencil
13¹¹/₁₆ x 6³/₁₆ in. (34.8 x 15.8 cm.)†
Provenance: James Goodman Gallery, New York.
Exhibition: *Group Show,* Dwan Gallery, Los Angeles, 1962.
Literature: Secunda, Arthur, "Group Show, Dwan Gallery," *Artforum,* vol. I, no. 1, September 1962, p. 8, ill. p. 9.

31. *Montauk Highway,* 1958
Oil on canvas
59 x 48 in. (149.8 x 121.9 cm.)
Provenance: Sidney Janis Gallery, New York.
Exhibitions: The UCLA Art Gallery, University of California, Los Angeles, long-term loan, 1959–60. *Modern Masters in West Coast Collections,* San Francisco Museum of Art, 1960. *The Theater Collects American Art,* Whitney Museum of American Art, New York, 1961. *New York School: The First Generation—Paintings of the 1940s and 1950s,* Los Angeles County Museum of Art, 1965. *Hollywood Collects,* Otis Art Institute, Los Angeles, 1970. *Collector's Choice,* Los Angeles Institute of Contemporary Art, 1975. *Willem de Kooning: Works from 1951–1981,* Guild Hall Museum, East Hampton, New York, 1981.
Literature: Hess, Thomas B., *Willem de Kooning,* George Braziller, Inc., New York, 1959, plate 4.

32. *Woman Study,* 1962
Charcoal
10⅞ x 8⅜ in. (27.6 x 21.2 cm.)†
Provenance: Paul Kantor Gallery, Beverly Hills.

33. *Woman Study,* 1962
Charcoal
10⅞ x 8⅜ in. (27.6 x 21.2 cm.)†
Provenance: Paul Kantor Gallery, Beverly Hills.

• 34. *Untitled,* 1962
(inscribed "To Michael from Bill")
Charcoal
10 x 8 in. (25.4 x 20.2 cm.)†
Provenance: Gift of the artist.

35. *Springs Hollow,* 1965
Oil on paper
19½ x 24⅞ in. (49.5 x 63.2 cm.)
Provenance: Jerrold Morris Gallery, Toronto. James Goodman Gallery, New York.
Exhibition: *5 American Painters: Recent Work,* UCSB Art Galleries, University of California, Santa Barbara, 1974.
Literature: Plous, Phyllis, *5 American Painters: Recent Work,* exh. cat., 1974, cat. no. 1, ill. p. 7.

• 36. *Untitled,* c. 1970
Oil on newsprint, mounted on linen
22⅜ x 29¼ in. (56.8 x 74.3 cm.)
Provenance: Private Collection, New York (acquired from the artist). Adler Gallery, Los Angeles.

37. *Figure V,* 1970
Bronze 1/6
14 x 10⅝ x 2¼ in. (35.6 x 27 x 5.7 cm.)
Provenance: Sidney Janis Gallery, New York.

38. *Reflections—To Kermit for Our Trip to Japan,* 1970
Lithograph 20/28
50¼ x 34¾ in. (127.6 x 88.3 cm.)†
Provenance: Betty Gold/Fine Modern Prints, Los Angeles.

39. *Clam Digger,* 1970
Lithograph 15/34
40¼ x 28⅛ in. (102.2 x 71.4 cm.)
Provenance: Betty Gold/Fine Modern Prints, Los Angeles.

RICHARD DIEBENKORN
American, b. 1922

40. *Untitled,* 1952
Watercolor
13¾ x 12¼ in. (35 x 31.1 cm.)†
Provenance: Paul Kantor Gallery, Beverly Hills.
Exhibition: *Richard Diebenkorn,* Pasadena Art Museum, California, 1960.

• 41. *Untitled,* 1954
Watercolor, pencil, and crayon
12 x 9 in. (30.5 x 22.8 cm.)†
Provenance: James Goodman Gallery, Buffalo, New York. B. C. Holland Gallery, Chicago.
Exhibition: *Richard Diebenkorn: Drawings, 1943–1973,* Mary Porter Sesnon Gallery, University of California, Santa Cruz, 1974.
Literature: *Drawings and Sculpture,* James Goodman Gallery, Buffalo, New York, 1964, cat. no. 8, ill. p. 2.

42. *Berkeley,* 1955
Oil on canvas
24 x 21⅛ in. (61 x 53.6 cm.)
Provenance: Paul Kantor Gallery, Beverly Hills.
Exhibitions: The UCLA Art Gallery, University of California, Los Angeles, long-term loan, 1959–60. *Richard Diebenkorn,* Pasadena Art Museum, California, 1960.

43. *Man and Window,* 1956
Ink and watercolor
14 x 17 in. (35.5 x 43.2 cm.)†
Provenance: Poindexter Gallery, New York.
Exhibitions: The UCLA Art Gallery, University of California, Los Angeles, long-term loan, 1959–60. *Richard Diebenkorn,* Pasadena Art Museum, California, 1960. *Richard Diebenkorn: Drawings, 1943–1973,* Mary Porter Sesnon Gallery, University of California, Santa Cruz, 1974. *Richard Diebenkorn—Paintings and Drawings, 1943–1976,* Albright-Knox Art Gallery, Buffalo, New York, 1977 (traveled to Cincinnati Art Museum, Ohio; Corcoran Gallery of Art, Washington, D.C.; Whitney Museum of American Art, New York; Los Angeles County Museum of Art; and The Oakland Museum, California).
Literature: *Richard Diebenkorn—Paintings and Drawings, 1943–1976,* exh. cat., 1977, cat. no. 14.

GUY DILL
American, b. 1946

44. *Model,* 1975
Wood and metal with paint
19 x 24 x 5¼ in. (48.2 x 61 x 13.3 cm.)
Provenance: Pace Gallery, New York.

PAUL DILLON
American, b. 1943

45. *Ugly Duckling,* 1974
Newsprint on canvas
29⁵/₁₆ x 31¹⁵/₁₆ in. (74.5 x 81.2 cm.)
Provenance: Ellie Blankfort Gallery, Los Angeles.
Exhibitions: *Collector's Choice,* Los Angeles Institute of Contemporary Art, 1975.

• 46. *Untitled,* 1975
Rubber stamping and acrylic on paper
18¼ x 17⅞ in. (46.3 x 45.4 cm.)
Provenance: Ellie Blankfort Gallery, Los Angeles.

JULES ENGEL
American, b. 1917

47. *Cityscape* (1 of 3), 1977–78
Screenprint 5/25
29 x 17⁵/₁₆ in. (73.7 x 44 cm.)
Provenance: Acquired from the artist.

48. *Cityscape* (2 of 3), 1977–78
Screenprint 5/25
28⅛ x 18⁵/₁₆ in. (71.3 x 46.5 cm.)
Provenance: Acquired from the artist.

49. *Cityscape* (3 of 3), 1977–78
Screenprint 5/25
23¾ x 17⁵/₁₆ in. (60.3 x 44 cm.)
Provenance: Acquired from the artist.

LLYN FOULKES
American, b. 1934

50. *The Stem of Summer Shoot,* 1961
Collage with pencil and ink
17⁵/₁₆ x 23¹/₁₆ in. (44 x 58.5 cm.)
Provenance: Ferus Gallery, Los Angeles.
Exhibitions: *Llyn Foulkes,* Oakland Art Museum, California, 1964. *Llyn Foulkes,* Newport Harbor Art Museum, Newport Beach, California, 1974. *The Last Time I Saw Ferus,* Newport Harbor Art Museum, Newport Beach, California, 1976.

51. *Untitled,* 1962
Collage
7⅜ x 5⅝ in. (18.7 x 14.3 cm.)†
Provenance: Dilexi Gallery, Los Angeles.

CHARLES FRAZIER
American, b. 1930

52. *Anno Domini 1962,* 1962
Sculptmetal over toy elements
19 1/2 x 14 1/2 x 14 1/2 in. (49.5 x 36.8 x 36.8 cm.)
Provenance: Huysman Gallery, Los Angeles.
Exhibition: *Collector's Choice,* Lytton Center of the Visual Arts, Los Angeles, 1964.

WALTER GABRIELSON
American, b. 1935

53. *Imperious Lady,* 1980
Oil on canvas
29 15/16 x 29 15/16 in. (76 x 76 cm.)
Provenance: Art Space Gallery, Los Angeles.
Exhibition: *Portraits,* Art Gallery, University of California, Irvine, 1981.

SONIA GECHTOFF
American, b. 1926

54. *Untitled,* 1957
(related to *Meeting of Lovers*)
Pencil
40 1/2 x 52 in. (102.9 x 132.1 cm.)
L.2364.63-27
Provenance: Ferus Gallery, Los Angeles.
Exhibition: *Twentieth-Century Drawing,* Art Center in La Jolla, California, 1960.
Literature: *Twentieth-Century Drawing,* exh. cat., 1960, cat. no. 28.

YUVAL GOLAN
Israeli, b. 1944

55. *Untitled,* 1977
Color etching and aquatint with embossing 2/100
13 7/16 x 23 1/16 in. (34.1 x 58.6 cm.)†
Provenance: Acquired from the artist.

JOE GOODE
American, b. 1937

56. *Untitled,* c. 1960–61
Oil on paper
9 1/2 x 8 5/8 in. (24.1 x 21.9 cm.)
Provenance: Huysman Gallery, Los Angeles.

57. *Vandalism,* 1973–74
Oil on canvasboard
17 11/16 x 23 11/16 in. (44.9 x 60.2 cm.)†
Provenance: Nicholas Wilder Gallery, Los Angeles.

ROBERT GOODNOUGH
American, b. 1917

58. *Abstract No. 4, "Pipes,"* 1956
Oil on canvas
44 1/4 x 46 in. (112.4 x 116.8 cm.)
Provenance: Tibor de Nagy Gallery, New York. Dwan Gallery, Los Angeles.

59. *The Boat Ride,* 1960
Colored crayon, ink, and watercolor
8 1/8 x 10 11/16 in. (20.6 x 27.1 cm.)
Provenance: Acquired from Abe Adler.

ARSHILE GORKY
American, b. Armenia, 1904–1948

60. *Untitled* (study for *The Calendars*), c. 1946
Oil on canvas
9 5/16 x 10 3/4 in. (23.7 x 27.3 cm.)
Provenance: Estate of Arshile Gorky. Obelisco Gallery, Rome. World House Gallery, New York. Paul Kantor Gallery, Beverly Hills.
Exhibition: The UCLA Art Gallery, University of California, Los Angeles, long-term loan, 1959–60.
Literature: Goldwater, Robert, *Arshile Gorky,* New York University Press, 1979. Rand, Harry, *Arshile Gorky: The Implications of Symbols,* Allenheld & Schram, Montclair, New Jersey, 1981, fig. 8–7, p. 120. Rosenberg, Harold, *Arshile Gorky: The Man, the Time, the Idea,* New York, Horizon Press, 1962, p. 87.

61. *Untitled,* c. 1947
Pencil and colored crayon
17 1/8 x 23 1/8 in. (43.5 x 58.7 cm.)†
Provenance: Noah Goldowsky, Inc., New York. Allan Stone Galleries, Inc., New York. James Goodman Gallery, New York.
Exhibition: *Arshile Gorky,* Allan Stone Galleries, Inc., New York, 1972.

ROBERT GRAHAM
American, b. Mexico, 1938

• 62. *Untitled,* 1975
Porcelain, negative relief
8 5/8 x 10 1/8 in. (21.9 x 25.6 cm.)
Provenance: Nicholas Wilder Gallery, Los Angeles.

• 63. *Untitled,* 1975
Gilded bronze relief 5/6
5 7/8 x 3 1/8 in. (14.9 x 7.9 cm.)
Provenance: St. Augustine School, Rare Day Sale, Santa Monica, California.

PHILIP GUSTON
American, b. Canada, 1913–1980

64. *Hester,* 1957
Oil on paper, mounted on board
35 1/2 x 24 1/4 in. (90.2 x 62.2 cm.)
Provenance: Paul Kantor Gallery, Los Angeles.
Exhibitions: *Philip Guston,* Los Angeles County Museum of Art, 1963. *Recent American Paintings,* University Art Museum, University of Texas, Austin, 1964.
Literature: Goodall, Donald B., *Recent American Paintings,* exh. cat., 1964, cat. no. 16, ill. inside back cover (installation view).

65. *Mott III,* 1958
Oil on paper, mounted on board
19 5/8 x 24 in. (49.9 x 61 cm.)†
Provenance: Paul Kantor Gallery, Los Angeles.

66. *Study for the Desert,* 1974
Charcoal
17 15/16 x 23 3/8 in. (45.6 x 59.4 cm.)†
Provenance: Marlborough Gallery, New York. David McKee Gallery, Inc., New York.
Exhibition: *Philip Guston,* David McKee Gallery, Inc., New York, 1974.
Literature: *Philip Guston,* exh. cat., 1974, cat. no. 7.

• 67. *Shoes,* 1980
Lithograph 21/50
20 x 30 in. (50.8 x 76.2 cm.)
Provenance: Gemini G.E.L.

MAXWELL HENDLER
American, b. 1938

68. *Venice Beach in the Rain,* 1975
Watercolor
6 1/8 x 7 3/8 in. (15.5 x 18.7 cm.)†
Provenance: Acquired from the artist.

69. *Abnormal Subject Matter,* 1976
Watercolor
8 x 9 5/16 in. (20.3 x 23.7 cm.)
Provenance: Acquired from the artist.

GEORGE HERMS
American, b. 1935

70. *Tail Light,* 1973
Mixed media
13 13/16 x 11 3/8 in. (35.1 x 28.9 cm.)
Provenance: L.A. Louver, Venice, California.

DAVID HOCKNEY
English, b. 1937

71. *Peter on Bed Seated,* 1968
Ink
16 3/4 x 13 3/4 in. (42.5 x 34.9 cm.)†
Provenance: Kasmin Ltd., London. Greer Gallery, New York.

C. B. HUNT (Bryan Hunt)
American, b. 1947

72. *Lamination,* 1974
Collage
22 1/2 x 30 in. (57.2 x 76.2 cm.)†
Provenance: Ellie Blankfort Gallery, Los Angeles.

ALFRED JENSEN
American, b. Guatemala, 1903–1981

73. *Des Bild der Sonne (Picture of the Sun),* 1966
Oil and ink on paper
29 x 23 1/8 in. (73.7 x 58.7 cm.)†
Provenance: Rolf Nelson Gallery, Los Angeles.

JASPER JOHNS
American, b. 1930

74. *Flashlight,* 1967–69
Etching and aquatint 33/40
25 7/8 x 19 3/4 in. (65.7 x 50.2 cm.)†
Provenance: Betty Gold/Fine Modern Prints, Los Angeles.

DANIEL LARUE JOHNSON
American, b. 1938

75. *The Big Steal #1,* 1962–63
Oil and assemblage on canvas
42 5/8 x 41 in. (108.3 x 104.1 cm.)
Provenance: Acquired from the artist.
Exhibitions: Pasadena Art Museum, California, long-term loan, 1963. The Oakland Museum, California, 1969.

LESTER F. JOHNSON
American, b. 1919

76. *Untitled,* c. 1961
Oil on paper
25 7/8 x 39 15/16 in. (65.7 x 101.5 cm.)
Provenance: Felix Landau Gallery, Los Angeles.

EARL KERKHAM
American, 1891–1965

77. *Untitled,* 1953
Watercolor
18 1/2 x 23 1/4 in. (47 x 59.1 cm.)†
Provenance: Greer Gallery, New York.

EDWARD KIENHOLZ
American, b. 1927

78. *Untitled,* 1956 (inscribed "for Mike and Dorothy")
Wood construction
35 7/8 x 26 1/4 in. (91.2 x 66.7 cm.)
Provenance: Ferus Gallery, Los Angeles.
Exhibition: The UCLA Art Gallery, University of California, Los Angeles, long-term loan, 1959–60.

79. *Untitled,* 1957
Watercolor with crayon and varnish
14 15/16 x 19 5/8 in. (38 x 49.8 cm.)†
Provenance: Gift of the artist.

80. *The U.S. Duck, or Home from the Summit,* 1960
Construction
26 7/16 x 21 1/4 x 6 in. (67.2 x 54 x 15.2 cm.)
Provenance: Ferus Gallery, Los Angeles.
Exhibitions: *Edward Kienholz,* Los Angeles County Museum of Art, 1966. Westside Jewish Community Center, Los Angeles, annual exhibition. *The Last Time I Saw Ferus,* Newport Harbor Art Museum, Newport Beach, California, 1976. *Modern Sculpture,* Mary Porter Sesnon Gallery, University of California, Santa Cruz, 1977.
Literature: Tuchman, Maurice, *Edward Kienholz,* exh. cat., 1966, ill. p. 22.

81. *The American Way, II,* 1960
Construction
22¾ x 22¼ x 8 in. (57.8 x
56.5 x 20.3 cm.)
Provenance: Acquired by contract
from the artist.
Exhibitions: *Edward Kienholz,* Los
Angeles County Museum of Art,
1966. *50's Abstract,* Conejo Valley
Art Museum, Thousand Oaks,
California, 1980.
Literature: *50's Abstract,* exh. cat.,
1980, ill. (unpaginated). Tuchman,
Maurice, *Edward Kienholz,* exh. cat.,
1966, ill. p. 22.

82. *For Rockwell Portable Saw 596,*
1969
Watercolor and rubber stamping in
galvanized metal frame
12⅛ x 16³⁄₁₆ in. (30.8 x 41.1 cm.)
Provenance: Eugenia Butler Gallery,
Los Angeles.

• 83. *Merry Xmas,* 1969
Watercolor and rubber stamping in
galvanized metal frame 1/10
8⁵⁄₁₆ x 12³⁄₁₆ in. (21.1 x 31 cm.)
Provenance: Gift of the artist.

84. *The Portable War Memorial 1968,*
1970
Etching on galvanized metal with
paint
22¼ x 33¼ in. (56.5 x 84.4 cm.)
Provenance: Acquired from the artist.

• 85. *H.I.D. #6,* 1973
Mixed-media construction
23¾ x 23¾ x 1½ in.
(60.3 x 60.3 x 3.8 cm.)
Provenance: L.A. Louver, Venice.

R. B. KITAJ
American, b. 1932

86. *Dismantling the Red Tent,* 1963–64
Oil and collage on canvas
48 x 48 in. (121.9 x 121.9 cm.)
Provenance: Marlborough Fine Art
Ltd., London.
Exhibitions: *Painting & Sculpture of a
Decade: 54–65,* The Tate Gallery,
London, 1964. *Contemporary British
Painting and Sculpture from the Collec-
tion of the Albright-Knox Art Gallery
and Special Loans,* Albright-Knox
Gallery, Buffalo, New York, 1964.
R. B. Kitaj, Marlborough-
Gerson, New York, 1965. *R. B. Kitaj:
Paintings and Prints,* Los Angeles
County Museum of Art, 1965. *R. B.
Kitaj,* Cleveland Museum of Art,
Ohio, 1967. *Dine/Kitaj,* Cincinnati
Art Museum, Ohio, 1973. *R. B.
Kitaj,* Hirshhorn Museum and
Sculpture Garden, Washington,
D.C., 1981–82 (traveled to Cleveland
Museum of Art, Ohio; Städtisches
Kunsthalle Düsseldorf, West
Germany).

Literature: Boyle, Richard J., *Dine/
Kitaj,* exh. cat., 1973, cat. no. 24.
Shannon, Joe, *R. B. Kitaj,* exh. cat.,
Smithsonian Institution Press,
Washington, D.C., 1981, cat. no. 13.

87. *Photography and Philosophy,* 1964
(inscribed "for Michael Blankfort
from R. B. Kitaj [proof] 1964")
Screenprint, proof (edition of 40,
published by Marlborough Graphics)
23 x 36 in. (58.4 x 91.4 cm.)
Provenance: Marlborough Fine Art
Ltd., London.

88. *Errata,* 1964
Screenprint 15/40 (published by
Marlborough Graphics)
35¹⁵⁄₁₆ x 23¹⁄₁₆ in. (91.3 x 58.5 cm.)
Provenance: Marlborough Fine Art
Ltd., London.

89. *Acheson Go Home,* 1964
Screenprint 15/40 (published by
Marlborough Graphics)
35⅞ x 23 in. (91.1 x 58.4 cm.)
Provenance: Marlborough Fine Art
Ltd., London.

90. *The Flood of Laymen,* 1964
Screenprint 67/70 (published by
Marlborough Graphics)
32½ x 22⁵⁄₁₆ in. (82.6 x 56.6 cm.)
Provenance: Marlborough Fine Art
Ltd., London.

91. *Good God Where is the King? or
Where is Count Hadik?,* 1964
Screenprint 33/40 (published by
Marlborough Graphics)
35¹⁵⁄₁₆ x 23 in. (91.3 x 58.4 cm.)
Provenance: Marlborough Fine Art
Ltd., London.

• 92. *The Desire for Lunch is a Bourgeois
Obsessional Neurosis or Grey
Schizoids,* 1965 (inscribed "for
Dorothy with love, Kitaj")
Screenprint, unnumbered (edition of
70, published by Marlborough
Graphics)
29¾ x 20¼ in. (75.6 x 51.4 cm.)†
Provenance: Marlborough Fine Art
Ltd., London.

93. *World Ruin Through Black Magic*
(1 of 2), 1965
Screenprint 16/70 (published by
Marlborough Graphics)
27 x 38⁹⁄₁₆ in. (68.6 x 97.9 cm.)
Provenance: Marlborough Fine Art
Ltd., London.

94. *World Ruin Through Black Magic*
(2 of 2), 1965
Screenprint, unnumbered (published
by Marlborough Graphics)
27³⁄₁₆ x 38⁷⁄₁₆ in. (69.1 x 97.7 cm.)
Provenance: Marlborough Fine Art
Ltd., London.

95. *Mort,* 1966
Screenprint 3/70 (published by
Marlborough Graphics)
39⅞ x 27⅛ in. (101.3 x 68.8 cm.)
Provenance: Marlborough Fine Art
Ltd., London.

96. *Walter Benjamin,* 1966 (inscribed
"for Mike")
Lithograph 4/10 (published by
Marlborough Graphics)
13 x 9⅞ in. (33 x 25.1 cm.)†
Provenance: Marlborough Fine Art
Ltd., London.

97. *Kenneth Rexroth,* 1969 (inscribed
"for Mike with love, Kitaj")
Screenprint, unnumbered (edition of
70, published by Marlborough
Graphics)
20 x 29¾ in. (50.8 x 75.5 cm.)
Provenance: Marlborough Fine Art
Ltd., London.

• 98. *Bub and Sis,* 1969–70 (from: *In
Our Time/Covers for a Small Library/
After the Life for the Most Part*)
Screenprint, unnumbered (edition of
150, published by Marlborough
Graphics)
30¹³⁄₁₆ x 22⁷⁄₁₆ in. (78.3 x 57 cm.)†
Provenance: Marlborough Fine Art
Ltd., London.

• 99. *Fighting the Traffic in Young Girls,*
1969–70 (from: *In Our Time/Covers
for a Small Library/After the Life for
the Most Part*)
Screenprint, unnumbered (edition of
150, published by Marlborough
Graphics)
30⁷⁄₁₆ x 22½ in. (77.3 x 57.1 cm.)†
Provenance: Marlborough Fine Art
Ltd., London.

100. *Immortal Portraits,* c. 1971
Screenprint 16/70 (published by
Marlborough Graphics)
28⅛ x 44½ in. (71.3 x 113.1 cm.)†
Provenance: Marlborough Fine Art
Ltd., London.

101. *Terese,* 1978
Pastel and charcoal
22 x 15 in. (55.9 x 38.1 cm.)†
Provenance: Marlborough Gallery,
New York.

102. *Two London Painters: Frank
Auerbach and Sandra Fisher,* 1979
Pastel and charcoal
22⅛ x 30⅞ in. (56.2 x 78.4 cm.)†
Provenance: Marlborough Gallery,
New York. The Margo Feiden
Galleries, New York. L.A. Louver,
Venice, California.
Exhibitions: *This Knot of Life,* L.A.
Louver, Venice, California, 1979.
R. B. Kitaj, Hirshhorn Museum and
Sculpture Garden, Washington,
D.C., 1981–82 (traveled to Cleveland
Museum of Art, Ohio; Städtisches
Kunsthalle Düsseldorf, West
Germany).

Literature: Shannon, Joe, *R. B. Kitaj,*
exh. cat., Smithsonian Institution
Press, Washington, D.C., 1981, cat.
no. 88.

YVES KLEIN
French, 1928–1962

103. *Anthropometrie (ANT 159),* 1962
Oil on paper
25 x 15¼ in. (63.5 x 38.7 cm.)
Provenance: Collection of Mme.
Yves Klein.

• 104. *IKB Monochrome (IKB 218),* 1962
Oil on cloth on board
25¾ x 19⅝ in. (65.4 x 49.8 cm.)
Provenance: Acquired from the artist.
Exhibitions: *Serial Imagery,* Pasadena
Art Museum, California, 1968
(traveled to Henry Art Gallery, Uni-
versity of Washington, Seattle; The
Santa Barbara Museum of Art,
California).
Literature: Coplans, John, *Serial Im-
agery,* exh. cat., 1968, cat. no. 147,
color plate p. 65.

105. *Immaterial Pictorial Sensitivity
Zone, No. 01, Series 4,* 1962
Documentary photographs
Provenance: Acquired from the artist.
Exhibitions of documentary photo-
graphs: *Yves Klein Retrospective,*
Tokyo Gallery, Japan, 1962. *Yves
Klein: 1928–1962,* The Tate Gallery,
London, 1974. *Yves Klein,* National
Galerie, Berlin and Neuer Berliner
Kunstverein, 1976 (traveled to Städ-
tisches Kunsthalle, Düsseldorf).
Literature: Compton, Michael, *Yves
Klein: 1928–1962,* exh. cat., 1974, ill.
pp. 76–77.

FRANZ KLINE
American, 1910–1962

• 106. *Shaft,* 1955
Oil on canvas
24 x 29¹⁄₁₆ in. (61 x 73.8 cm.)
Provenance: Martin Janis Gallery,
North Hollywood.
Exhibitions: *Kline,* Sidney Janis Gal-
lery, New York, 1956. The UCLA
Art Gallery, University of Califor-
nia, Los Angeles, long-term loan,
1959–60. *Franz Kline, Paintings
1950–61,* Dwan Gallery, Los
Angeles, 1963. *Black and White Are
Colors,* Montgomery Art Gallery,
Pomona College, Claremont,
California, 1979.
Literature: Langsner, Jules, "Franz
Kline, Calligraphy and Information
Theory," *Art International,* March 25,
1963, pp. 25–29, ill. p. 26. Langsner,
Jules, *Franz Kline, Paintings 1950–61,*
exh. cat., 1963, cat. no. 3. *New Paint-
ings by Franz Kline,* exh. cat., 1960,
cat. no. 27. Rubin, David S., and
David W. Steadman, *Black and White
Are Colors,* exh. cat., 1979, cat. no. 3,
ill. p. 33.

JOSEPH KOSUTH
American, b. 1945

107. *Untitled*, 1968
Rubber stamping 9/10
17¹/₁₆ x 14 in. (43.2 x 35.6 cm.)†
Provenance: Eugenia Butler Gallery,
Los Angeles. Los Angeles County
Museum of Art, Art Rental Gallery.

RICO LEBRUN
American, 1900–1964

108. *Addio Cataluña*, 1939
Ink
11¹¹/₁₆ x 15³/₄ in. (29.7 x 40 cm.)†
Provenance: Acquired from the art-
ist's studio posthumously.

ALFRED LESLIE
American, b. 1927

109. *Abstraction I*, 1960
Oil on cardboard
8 x 8 in. (20.3 x 20.3 cm.)
Provenance: Frank Perls Gallery,
Beverly Hills.

JAMES McGARRELL
American, b. 1930

110. *Auslese*, n.d.
Pencil and charcoal
26³/₈ x 39³/₈ in. (67 x 100 cm.)†
Provenance: Frank Perls Gallery,
Beverly Hills.

LOREN MADSEN
American, b. 1943

111. *Corner piece—bricks & wire—
c. 6'l x 6'w x 3½'h*, 1974
Ink and pencil
18¹/₈ x 23¹/₄ in. (46 x 59 cm.)†
Provenance: Ellie Blankfort Gallery,
Los Angeles.

112. *Brick Drawing (1 of 2)*, 1976
Rubber stamping
9¹³/₁₆ x 7³/₄ in. (24.9 x 19.7 cm.)†
Provenance: Ellie Blankfort Gallery,
Los Angeles.

113. *Brick Drawing (2 of 2)*, 1976
Rubber stamping
9¹³/₁₆ x 7³/₄ in. (24.9 x 19.7 cm.)†
Provenance: Ellie Blankfort Gallery,
Los Angeles.

JOHN MARIN
American, 1870–1953

• 114. *New Mexico*, 1930
Watercolor
13¹/₄ x 16½ in. (33.6 x 41.9 cm.)†
Provenance: An American Place,
New York. The Walden School,
New York.
Exhibition: *Marin in New Mexico
1929 and 1930*, Art Museum, Univer-
sity of New Mexico, Albuquerque,
1968 (traveled to Marion Koogler
McNay Art Institute, San Antonio,
Texas; Amon Carter Museum, Fort
Worth, Texas).

• 115. *Sailboat*, 1932
Etching (signed outside the plate)
6⁵/₈ x 9³/₁₆ in. (16.8 x 23.3 cm.)†
Provenance: The Downtown
Gallery, Inc., New York.
Literature: Zigrosser, Carl, *The
Complete Etchings of John Marin*, exh.
cat., Philadelphia Museum of Art,
1969, cover and cat. no. 155.

**SANDRA MENDELSOHN-
RUBIN**
American, b. 1947

116. *Van: From Venice Night*, 1979
Oil on canvas
9³/₁₆ x 12¹/₄ in. (23.3 x 31.1 cm.)
Provenance: L.A. Louver, Venice,
California.

ARNOLD MESCHES
American, b. 1923

117. *Jill's Mother #1*, 1976
Acrylic on canvas
11 x 11 in. (28 x 28 cm.)
Provenance: Acquired from the artist.

118. *Clarence Darrow*, 1977
Pencil
30 x 21⁷/₈ in. (76.2 x 55.6 cm.)
Provenance: Acquired from the artist.

• 119. *Mike Blankfort #1*, 1979
Pencil
10⁷/₈ x 10⁷/₈ in. (27.6 x 27.6 cm.)†
Provenance: Acquired from the artist.

120. *Mike Blankfort #2*, 1980
Acrylic on canvas
59⁷/₈ x 51⁷/₈ in. (152.1 x 131.8 cm.)
Provenance: Acquired from the artist.

GEORGE MILLER
American, b. 1944

121. *Le Monde*, 1974
Mixed-media drawing
25³/₄ x 19⁷/₈ in. (65.4 x 50.5 cm.)†
Provenance: Acquired from the artist.
Exhibition: *Collector's Choice*, Los
Angeles Institute of Contemporary
Art, 1975.

122. *Pravda*, 1974
Mixed-media drawing
25³/₄ x 19³/₄ in. (65.4 x 50.2 cm.)
Provenance: Acquired from the artist.
Exhibition: *Collector's Choice*, Los
Angeles Institute of Contemporary
Art, 1975.

JUDITH MILLER
American, b. 1943

123. *To B. 1943–1955*, 1974
Collage with ink, vellum, photo-
graphs, and ribbon
12¹/₈ x 21⁵/₈ in. (30.7 x 54.9 cm.)†
Provenance: Ellie Blankfort Gallery,
Los Angeles.
Exhibition: *Collector's Choice*, Los
Angeles Institute of Contemporary
Art, 1975.

MOSHE MOKADY
Israeli, b. Poland, 1902–1975

124. *Figure*, 1956
Oil on canvas
7¹/₄ x 6¹/₈ in. (18.4 x 15.5 cm.)†
Provenance: Acquired from the artist.

125. *The Sea of Galilee*, 1956
Oil on canvasboard
14 x 18⁷/₈ in. (35.6 x 48 cm.)†
Provenance: Acquired from the artist.
Exhibitions: *Exhibition of Israeli Art-
ists*, University of Judaism, Los
Angeles, 1958. The UCLA Art Gal-
lery, University of California, Los
Angeles, long-term loan, 1959–60.

EDWARD MOSES
American, b. 1926

126. *Page out of a Book*, 1959
Pencil and crayon
17 x 14 in. (43.2 x 35.6 cm.)†
Provenance: Huysman Gallery,
Los Angeles.

ROBERT MOTHERWELL
American, b. 1915

127. *Spanish Elegy XV*, 1953
Oil on canvasboard
12 x 16 in. (30.5 x 40.6 cm.)
Provenance: Paul Kantor Gallery,
Beverly Hills.
Exhibitions: *Robert Motherwell*,
Pasadena Art Museum, California,
1962. *50 Years of Beverly Hills*, Paul
Kantor Gallery, Beverly Hills, 1964.
*Robert Motherwell in California Collec-
tions*, Otis Art Institute Gallery, Los
Angeles, 1974–75.
Literature: *Robert Motherwell in
California Collections*, exh. cat., 1974,
cat. no. 14 (unpaginated).

LEE MULLICAN
American, b. 1919

128. *Untitled*, 1959
Oil on paper
19 x 12³/₄ in. (48.2 x 32.4 cm.)†
Provenance: Paul Kantor Gallery,
Beverly Hills.

MULTIPLE

129. *Seven Objects in a Box*, 1966
Mixed media 8/75 (published by
Tanglewood Press, New York)
a. **ALLAN D'ARCANGELO**
American, b. 1930
Side View Mirror, 1966
7¹/₄ x 4³/₄ x 6¹/₄ in.
(18.4 x 12.1 x 15.9 cm.)
b. **JIM DINE**
American, b. 1935
Rainbow Faucet, 1966
5½ x 2⁵/₈ x 4³/₄ in.
(14 x 6.7 x 12.1 cm.)
c. **ROY LICHTENSTEIN**
American, b. 1923
Sunrise, 1967
8⁹/₁₆ x 11 in. (21.7 x 28 cm.)

d. **CLAES OLDENBURG**
American, b. Sweden, 1929
Baked Potato, 1967
4³/₄ x 10⁷/₁₆ x 7³/₁₆ in.
(12.1 x 26.5 x 18.3 cm.)
Exhibitions: *Oldenburg: Works
in Edition*, Margo Leavin Gal-
lery, Los Angeles, 1971. *The
Fine Art of Food*, Lang Art Gal-
lery, Scripps College,
Claremont, California, 1974.
Literature: *Oldenburg: Works in
Edition*, exh. cat., 1971,
cat. no. 32.
e. **GEORGE SEGAL**
American, b. 1924
Chicken, 1966
17 x 17½ x 3½ in.
(43.2 x 44.4 x 8.9 cm.)
f. **ANDY WARHOL**
American, b. 1928
Kiss, 1967
12¹/₈ x 8 in.
(30.8 x 20.3 cm.)
g. **TOM WESSELMANN**
American, b. 1931
Little Nude, 1966
7³/₄ x 7⁵/₈ x 1 in.
(19.7 x 19.3 x 2.5 cm.)
Provenance: The Egg and the Eye,
Los Angeles.
Exhibition: *Multiples*, The Egg and
the Eye, Los Angeles, 1967.

BRUCE NAUMAN
American, b. 1941

130. *Untitled*, 1970
Lithograph 110/150 (from a suite
of 5)
25³/₄ x 25³/₄ in. (65.4 x 65.4 cm.)†

131. *Raw/War*, 1971
Lithograph 11/100
22³/₈ x 28¹/₈ in. (56.8 x 71.4 cm.)†
Provenance: Betty Gold/Fine
Modern Prints, Los Angeles.

LOUISE NEVELSON
American, b. Russia, 1900

132. *Verso*, 1959
Wood, nails, and paint
32¹/₁₆ x 28¹/₈ x 3¹/₈ in.
(81.4 x 71.4 x 7.9 cm.)
M.73.80
Provenance: David Herbert Gallery,
New York. The Michael and Dorothy
Blankfort Collection (gift to the
Los Angeles County Museum of
Art, 1973).
Exhibitions: *Modern Masters in West
Coast Collections*, San Francisco
Museum of Art, 1960. *7 + 5 Sculptors
in the 1950s*, UCSB Art Galleries,
University of California, Santa Bar-
bara, 1976 (traveled to Phoenix Art
Museum, Arizona).
Literature: Plous, Phyllis, *7 + 5
Sculptors in the 1950s*, exh. cat., Uni-
versity of California Press, Berkeley
and Los Angeles, 1976, cat. no. 47,
ill. p. 82.

CLAES OLDENBURG
American, b. Sweden, 1929

133. *Visualization of a Giant Soft Sculpture in the Form of a Shirt with Tie (Shirt on Its Side)*, 1963
Watercolor and crayon
14 x 16½ in. (35.5 x 41.9 cm.)†
Provenance: Dwan Gallery, Los Angeles. Collection of Dr. and Mrs. Nathan Alpers. Dwan Gallery, Los Angeles.
Exhibitions: *Claes Oldenburg 1963–1966*, Moderna Museet, Stockholm, 1966. *Twentieth-Century Works on Paper*, Art Gallery, University of California, Irvine, 1968 (traveled to Memorial Union Art Gallery, University of California, Davis). *Claes Oldenburg*, The Museum of Modern Art, New York, 1969–70 (traveled to Stedelijk Museum, Amsterdam; The Tate Gallery, London; Centre National d'Art Contemporain, Paris). *Twentieth-Century American Drawing: Three Avant-Garde Generations*, The Solomon R. Guggenheim Museum, New York, 1975–76. *American Drawings*, Staatliche Kunsthalle Baden-Baden, 1976. *Claes Oldenburg*, Stedelijk Museum, Amsterdam, 1977.
Literature: Baro, Gene, *Claes Oldenburg: Drawings and Prints*, Chelsea House, London, New York, 1969, color plate no. 170. Rose, Barbara, *Claes Oldenburg*, exh. cat., 1969, cat. no. 155. Van Bruggen, Coosje, *Claes Oldenburg*, exh. cat., 1977, cat. no. 43, ill. p. 36.

• 134. *Proposed Colossal Monument for Ellis Island: Frankfurter with Tomato and Toothpick*, 1965
Watercolor and pencil
18⅜ x 23⅜ in. (46.6 x 59.3 cm.)†
Provenance: Sidney Janis Gallery, New York.
Exhibitions: *Oldenburg*, Sidney Janis Gallery, New York, 1966. *Claes Oldenburg 1963–1966*, Moderna Museet, Stockholm, 1966. *Proposed Monuments and Related Drawings by Claes Oldenburg*, Museum of Contemporary Art, Chicago, 1967 (traveled to Krannert Art Museum, University of Illinois, Champaign). *Claes Oldenburg*, The Museum of Modern Art, New York, 1969–70 (traveled to Stedelijk Museum, Amsterdam; The Tate Gallery, London; Centre National d'Art Contemporain, Paris). *Claes Oldenburg: Object into Monument*, Pasadena Art Museum, California, 1971–72. *American Master Drawings and Watercolors*, American Federation of Arts, San Francisco, 1977.

Literature: Baro, Gene, *Claes Oldenburg: Drawings and Prints*, Chelsea House, London, New York, 1969. *Claes Oldenburg*, exh. cat., 1966, cat. no. 32. Fahlström, Öyvind, and Ulf Linde, *Claes Oldenburg 1963–1966*, exh. cat., 1966, cat. no. 40. Rose, Barbara, *Claes Oldenburg*, exh. cat., 1969, cat. no. 182, color plate p. 116.

135. *Slice of Wedding Cake*, 1966
Plaster (edition size unknown)
5⅞ x 6⁹/₁₆ x 2¼ in. (14.9 x 16.6 x 5.7 cm.)
Provenance: Gift of the artist (given to guests at the wedding of James and Judith Elliott in Malibu, California, 1966).
Exhibition: *Oldenburg: Works in Edition*, Margo Leavin Gallery, Los Angeles, 1971.
Literature: *Oldenburg: Works in Edition*, exh. cat., 1971, cat. no. 33.

136. *Toronto Drainpipe #1*, 1967 (three-dimensional study for *Toronto Drainpipe*)
Plaster, wood, and paint
21¾ x 12½ x 7 in. (55.7 x 31.8 x 17.8 cm.)
Provenance: Sidney Janis Gallery, New York.
Exhibition: *Claes Oldenburg: Object into Monument*, Pasadena Art Museum, California, 1971–72 (traveled to University Art Museum, University of California, Berkeley; William Rockhill Nelson Gallery of Art and Mary Atkins Museum of Fine Arts, Kansas City, Missouri; Fort Worth Art Center Museum, Texas; Des Moines Art Center, Iowa; Art Institute of Chicago).

137. *Ice Cream Print*, 1968
Lithograph 87/100
22⅛ x 15¾ in. (56.2 x 40 cm.)

RICHARD PETTIBONE
American, b. 1938

138. *Roy Lichtenstein. Seductive Girl. 1964*, 1965
Oil on canvas
10⅛ x 9 in. (25.7 x 22.9 cm.)

RICHARD POUSETTE-DART
American, b. 1916

139. *Chrome Image*, 1941
Oil on canvas
24 x 20 in. (61 x 50.8 cm.)
Provenance: Willard Gallery, New York. Merle Armitage, Los Angeles. Ernest Raboff Gallery, Los Angeles.

JOACHIM PROBST
American, 1913–1980

140. *Untitled*, 1956
Watercolor
10½ x 8¾ in. (26.7 x 22.2 cm.)†
Provenance: Greer Gallery, New York.

141. *February Christ*, 1957
Oil on board
39⅞ x 30 in. (101.2 x 76.2 cm.)
Provenance: Greer Gallery, New York.

142. *Untitled*, 1957
Watercolor and ink
22⅝ x 28¼ in. (57.4 x 71.8 cm.)†
Provenance: Greer Gallery, New York.

ARNULF RAINER
Austrian, b. 1929

143. *Selbstgeburt (Self-Birth)*, 1971
Photograph with pencil and crayon
23⅞ x 19⅞ in. (60.6 x 50.5 cm.)†
Provenance: Galerie Ariadne, New York. Ruth Schaffner Gallery, Los Angeles.

ROBERT RAUSCHENBERG
American, b. 1925

144. *Cardbird I*, 1971
Lithograph and collage on cardboard
37/75
44¾ x 30 in. (113.7 x 76.2 cm.)
Provenance: Leo Castelli Gallery, New York.

145. *Cardbird II*, 1971
Lithograph and collage on cardboard
37/75
54½ x 33⅝ in. (138.4 x 85.4 cm.)
Provenance: Leo Castelli Gallery, New York.

MAN RAY
American, 1890–1976

146. *Cadeau (Gift)*, 1963 (replica of 1921 original, signed by the artist)
Flat iron with nails 6/10
5½ x 3⁷/₁₆ x 3½ in. (14 x 8.7 x 8.9 cm.)
Provenance: Dwan Gallery, Los Angeles.
Exhibitions: *Man Ray*, Los Angeles County Museum of Art, 1966. *Ray: 1930's–1940's*, Los Angeles Art Association, 1972. *Man Ray: Inventor/Painter/Poet*, The New York Cultural Center, 1974–75 (traveled to Institute of Contemporary Arts, Ltd., London; Museo Civico di Turino). *200 Years of American Sculpture*, Whitney Museum of American Art, New York 1976. *Modern Sculpture*, Mary Porter Sesnon Art Gallery, University of California, Santa Cruz, 1977.
Literature: Langsner, Jules, *Man Ray*, exh. cat., 1966, cat. no. 149, ill. p. 121.

MANOLO RIVERA
Spanish, b. 1927

147. *Metamorphosis in Homage to Kafka*, 1959
Wire sculpture, framed in aluminum
39⁵/₁₆ x 29⁷/₁₆ in. (99.8 x 74.8 cm.)
Provenance: Galería Juana Mordó, Madrid.

LARRY RIVERS
American, b. 1923

• 148. *Yves Klien [Klein]*, 1961
Pencil
13 x 15½ in. (33 x 39.3 cm.)†
Provenance: Dwan Gallery, Los Angeles.
Exhibition: *Larry Rivers Retrospective*, Rose Art Museum, Brandeis University, Waltham, Massachusetts, 1965.
Literature: Simon, Sidney, "Larry Rivers," *Art International*, vol. X, no. 9, November 20, 1966, pp. 17–25.

RICHARDS RUBEN
American, b. 1925

149. *Dark of Day*, 1957
Watercolor
10¼ x 17½ in. (26 x 44.5 cm.)
Provenance: Paul Kantor Gallery, Beverly Hills.

150. *Untitled*, n.d.
Watercolor and pastel
14⅞ x 17 in. (37.8 x 43.2 cm.)
Provenance: Paul Kantor Gallery, Beverly Hills.

ANNE RYAN
American, 1889–1954

151. *Collage on Pink Paper*, 1952
Collage, paper, and fabric
6¹⁵/₁₆ x 5⅛ in. (17.6 x 13 cm.)
Provenance: Gift of the artist to Mr. Douglas M. Howell. Davis & Long Co., New York.

LUCAS SAMARAS
American, b. Greece, 1936

152. *Untitled*, 1963
Box, photographs, pins, and colored yarn
10¼ x 14⅜ x 8 in. (26.1 x 36.5 x 20.3 cm.) (closed)
Provenance: Dwan Gallery, Los Angeles.
Exhibitions: *Eight Sculptors: The Ambiguous Image*, Walker Art Center, Minneapolis, Minnesota, 1966. *Lucas Samaras: Boxes*, Museum of Contemporary Art, Chicago, 1971. *Lucas Samaras*, Whitney Museum of American Art, New York, 1972–73. *Lucas Samaras: Photo-Transformations*, The Art Galleries, California State University, Long Beach, 1975.
Literature: Friedman, Martin and Jan van der Marck, *Eight Sculptors: The Ambiguous Image*, exh. cat., 1966, cat. no. 21, ill. p. 36. Levin, Kim, *Lucas Samaras*, Harry N. Abrams, Inc., New York, 1975. Pincus-Witten, Robert, "Rosenquist and Samaras: The Obsessive Image and Post-Minimalism," *Artforum*, vol. XI, no. 1, September 1972, pp. 63–69, color plate p. 65. Samaras, Lucas, *Lucas Samaras*, exh. cat., 1972, cat. no. 204, ill. (unpaginated).

Siegfried, Joan C. and Stephen S. Prokopoff, *Lucas Samaras: Boxes*, exh. cat., 1971, ill. (unpaginated).

PETER SAUL
American, b. 1934

153. *Untitled*, 1960
Crayon and pastel
20¾ x 35 in. (52.7 x 88.9 cm.)
L.2364.63-25
Provenance: Rolf Nelson Gallery, Los Angeles.

154. *Untitled*, 1962
Oil on canvas
51⅛ x 59 in. (129.8 x 149.9 cm.)
Provenance: Galerie Denise Breteau, Paris.
Exhibition: *Pop Art U.S.A.*, Oakland Art Museum, California, 1963.
Literature: Coplans, John and Paul Mills, *Pop Art U.S.A.*, exh. cat., 1963, ill. p. 50.

ANTONIO SAURA
Spanish, b. 1930

155. *Retrato de Felipe II*, 1959
Oil on canvas
51 x 38 in. (129.5 x 96.5 cm.)
L.2364.61-3
Provenance: Galería Juana Mordó, Madrid.
Exhibition: Joslyn Art Center, Torrance, California, 1968.

156. *Retrato 71*, 1959
Oil on canvas
23⅝ x 28⅞ in. (60 x 73.3 cm.)
Provenance: Galería Juana Mordó, Madrid.

157. *Dama*, 1961
Oil on paper
11½ x 7⅞ in. (29.2 x 19.7 cm.)†
Provenance: Galería Juana Mordó, Madrid.

EGON SCHIELE
Austrian, 1890–1918

158. *Männlicher Akt. Selbstbildnis I. (Male Nude. Self-Portrait I.)*, 1912
Lithograph on vellum no. 21 (signed and dated outside the stone)
17⅝ x 15¾ in. (44.7 x 40 cm.)†
Provenance: Selected Artists Galleries, Inc., New York. Felix Landau Gallery, Los Angeles.
Literature: Chipp, Herschel B. and Karin Breuer, *The Human Image in German Expressionist Graphic Art from the Robert Gore Rifkind Foundation*, exh. cat., University Art Museum, University of California, Berkeley, 1981, cat. no. 112, ill. p. 21.

159. *Untitled*, 1918
Black crayon
18¼ x 11⅝ in. (46.3 x 29.5 cm.)†
Provenance: Felix Landau Gallery, Los Angeles. Grosvenor Gallery, London.

Exhibitions: *Viennese Expressionism: 1910–1924*, University Art Museum, University of California, Berkeley, 1963 (traveled to Pasadena Art Museum, California). *Works on Paper 1900–1960 from Southern California Collections*, Montgomery Art Gallery, Pomona College, Claremont, California, 1977 (traveled to M. H. de Young Memorial Museum, San Francisco).
Literature: Chipp, Herschel B., *Viennese Expressionism, 1910–1924*, exh. cat., University of California Press, Berkeley and Los Angeles, 1963, cat. no. 85. Steadman, David W., and Frederick S. Wight, *Works on Paper 1900–1960 from Southern California Collections*, exh. cat., 1977, cat. no. 65, ill. p. 77.

TERRY SCHOONHOVEN and VICTOR HENDERSON
American, b. 1945; American, b. 1939
(Los Angeles Fine Arts Squad)

160. *Isle of California*, 1971
Pencil and acrylic on photograph
29½ x 39½ in. (74.9 x 100.3 cm.)†
Provenance: Betty Gold/Fine Modern Prints, Los Angeles.

HASSEL SMITH
American, b. 1915

161. *Untitled*, 1957
Oil on canvas
68 x 46 in. (172.7 x 116.9 cm.)
M.64.8
Provenance: Ferus Gallery, Los Angeles. The Michael and Dorothy Blankfort Collection (gift to the Los Angeles County Museum of Art, 1964).
Exhibition: The UCLA Art Gallery, University of California, Los Angeles, long-term loan, 1959–60.

162. *Goofy Dufy*, 1958
Oil on canvas
68¹³⁄₁₆ x 38¹³⁄₁₆ in. (174.8 x 98.6 cm.)
Provenance: Ferus Gallery, Los Angeles.
Exhibitions: *Hassel Smith: A Selection of Paintings, 1948–1961*, Pasadena Art Museum, California, 1961. *Hassel Smith: Paintings 1954–1975*, San Francisco Museum of Art, 1975. *The Last Time I Saw Ferus*, Newport Harbor Art Museum, Newport Beach, California, 1976.
Literature: Hopps, Walter, *Hassel Smith: A Selection of Paintings, 1948–1961*, exh. cat., 1961, cat. no. 20.

SAUL STEINBERG
American, b. Rumania, 1914

• 163. *Rimbo Table*, 1973
Polychromed wood, oil on board, and etched metal
21¼ x 16⅜ in. (54 x 41.6 cm.)†
Provenance: Sidney Janis Gallery, New York.

JAMES STROMBOTNE
American, b. 1934

• 164. *Portrait in Red and Blue (The Smoker)*, 1958
Oil on canvas
38 x 30 in. (96.5 x 76.2 cm.)
Provenance: Frank Perls Gallery, Beverly Hills.

165. *Eight Illustrations for Dostoyevsky's Brothers Karamazov*, n.d.
Collotype 50/500 (1 to 200 signed)
11 x 8½ in. (27.9 x 21.6 cm.)
 I. Portrait
 II. Fyodor
 III. The Sensualists
 IV. In the Cottage
 V. The Grand Inquisitor
 VI. Grushenka
 VII. A Hymn and a Secret
VIII. Smerdiakov
Provenance: Frank Perls Gallery, Beverly Hills.

ANN THORNYCROFT
American, b. 1944

166. *Untitled 67*, 1978
Watercolor with pencil
29¾ x 22¼ in. (75.6 x 56.5 cm.)†
Provenance: Rosamund Felsen Gallery, Los Angeles.

FRANCISCO TOLEDO
Mexican, b. 1940

167. *The Attacker*, c. 1964
Watercolor
9½ x 11¾ in. (24.2 x 29.8 cm.)†
Provenance: Hamilton Galleries, Ltd., London.

ESTEBAN VICENTE
American, b. Spain, 1903

168. *Orange-Black*, 1958
Collage
25¾ x 16 in. (65.4 x 40.6 cm.)†
Provenance: Rose Fried Gallery, New York.
Exhibitions: The UCLA Art Gallery, University of California, Los Angeles, long-term loan, 1959–60. *Twentieth-Century Drawing*, The Art Center in La Jolla, California, 1960.
Literature: Price, Vincent and Donald Brewer, *Twentieth-Century Drawing*, exh. cat., 1960, cat. no. 95.

169. *Untitled*, 1961 (inscribed "To Dorothy & Michael")
Charcoal
16¾ x 22⅜ in. (42.5 x 56.8 cm.)†
Provenance: Gift of the artist.

• 170. *Comstock*, 1962
Collage
19½ x 24½ in. (49.5 x 62.3 cm.)†
Provenance: Gift of the artist.

EDOUARD VUILLARD
French, 1868–1940

171. *Le Clos Cézanne*, 1920
Pastel
8¾ x 11⅝ in. (22.2 x 29.5 cm.)†

Provenance: Collection Jacques Salomon, Paris. Grosvenor Gallery, London.

JUNE WAYNE
American, b. 1918

172. *Sea Change*, 1976
Lithograph, unnumbered
21 x 26½ in. (53.3 x 67.3 cm.)†
Provenance: Acquired from the artist.

CHARLES WHITE
American, 1918–1979

173. *I Have a Dream*, 1976
Lithograph 29/125
22½ x 30 in. (57.2 x 76.2 cm.)
Provenance: Los Angeles County Museum of Art, Graphic Arts Council Commission.

JOHN WHITE
American, b. 1937

174. *Landscape Notation*, 1974
Pencil, colored inks, and collage
22⅞ x 34 in. (58.1 x 86.4 cm.)†
Provenance: Betty Gold/Fine Modern Prints, Los Angeles.

• 175. *Con Errico CI #32*, 1981
Acrylic, pencil, and wash on paper
23 x 29 in. (58.4 x 73.7 cm.)
Provenance: Jan Baum Gallery, Los Angeles.

EMERSON WOELFFER
American, b. 1914

176. *Wrapping Paper*, 1958
Collage
17¹¹⁄₁₆ x 13¾ in. (44.9 x 34.9 cm.)†
Provenance: Paul Kantor Gallery, Beverly Hills.
Exhibition: *Emerson Woelffer*, Pasadena Art Museum, California, 1962.

177. *Orange Night*, 1961
Oil on canvas
14⅛ x 11 in. (35.8 x 27.9 cm.)
Provenance: Primus-Stuart Galleries, Los Angeles.
Exhibitions: *Emerson Woelffer*, Pasadena Art Museum, California, 1962. *Emerson Woelffer: A Survey Exhibition—The Years 1947–1974*, Newport Harbor Art Museum, Newport Beach, California, 1974.
Literature: Wescher, Paul and James B. Byrnes, *Emerson Woelffer: A Survey Exhibition—The Years 1947–1974*, exh. cat., 1974, cat. no. 30.

178. *Summer Poet #7*, 1978
Collage with painted paper
8 x 6 in. (20.2 x 15.2 cm.)†
Provenance: Adler Gallery, Los Angeles.